The Bulfinch
Pocket Dictionary of
Art Terms

THE

BULFINCH

POCKET

DICTIONARY

OF

ART

TERMS

THIRD

REVISED

EDITION

Dedicated to Mom and Dad, Robert and Manuelle Diamond, for their love and support

Third Revised Edition
Fourth Printing, 2001

Library of Congress Cataloging-in-Publication Data

Diamond, David
 The Bulfinch pocket dictionary of art terms.
 —3rd rev. ed. / David G. Diamond.
 p. cm.
 Rev. ed. of: The pocket dictionary of art terms / Julia M. Ehresmann. 2nd rev. ed. c1979
 "A Bulfinch Press Book"
 Includes bibliographical references.
 ISBN 0-8212-1905-7
 1. Art—Terminology. I. Ehresmann, Julia M. Pocket dictionary of art terms. II. Title.
 N33.D468 1992
 703—dc20 91-58791

Bulfinch Press is an imprint and trademark of Little, Brown and Company (Inc.)

Cover design by Jean Wilcox

Preface

There is no shortage of dictionaries of art terms. Every library has at least a modest number of them, and in the thirteen years that passed after the second revised edition of this dictionary was published, numerous new books appeared. Yet none has replaced this one, because neither the student, the museum-goer, the artist, the buyer of art, nor the casual follower of the contemporary art scene wants to go to a library each time an unfamiliar word is encountered. Help is needed—at hand—for definitions of words and phrases that are actually *in use*—in texts and scholarly books, in magazines and newspapers, in conversation, in auction catalogs, even on works of art.

This dictionary was written with the mobile inquirer in mind. It is small enough to travel easily and at the same time has enough substance to be a lasting reference work. In revising for this new edition, the selection of entries has been adjusted and expanded to accommodate changing usage and the widened interests of people who want and need to know about art.

Important revisions and additions have been made concerning art trends of the last twenty years. The latest movements and styles in artistic production are now explored and exemplary artists cited. Most importantly, theoretical terms from other disciplines such as anthropology (PRIMITIVISM), history (FEMINISM), linguistics (SEMIOTICS), and literature and philosophy (POSTMODERNISM) are included for the first time and their relevance to art is explained. These critical terms are increasingly important as cross-disciplinary studies continue to gain favor on college cam-

puses and in high schools. Finally, awareness of our architectural heritage is served by the addition of many definitions of styles as well as by the diagrams that begin this book.

The student will find more textbook and classroom terms than before. For students of art history, terms that are confusing or often misused (such as MAESTÀ and MAJESTAS DOMINI) are distinguished. For the studio art student, ambiguous terms like MEDIUM and VEHICLE are explained. The museum-goer will find definitions for terms curators use on labels (such as FL. and MOSAN). The art buyer can look up DEL. when considering the purchase of an engraving. And the casual reader will be able to find a concise definition for an aesthetic concept (FORMALISM) and definitions of many movements that either were not named in earlier editions (GRAFFITI ART) or which have since acquired more precise meanings (REGIONALISM). Cross-references, indicated by capital letters, augment individual definitions.

This third edition grounds the student or novice in terminology that ranges from the most basic technical information to the more difficult terrain of cultural studies and its impact on art production and art history, thereby bridging gaps that still exist in other compilations.

List of
Illustrations

1. Elements of Classical Orders

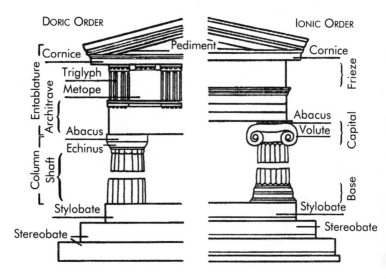

2. Greek Temple (ground plan)

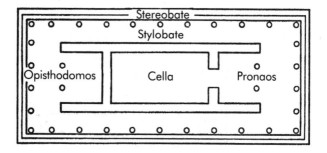

3. Early Christian Basilica (ground plan)

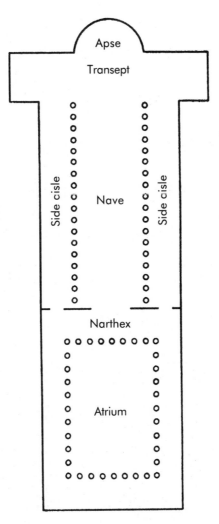

4. Gothic Cathedral (ground plan)

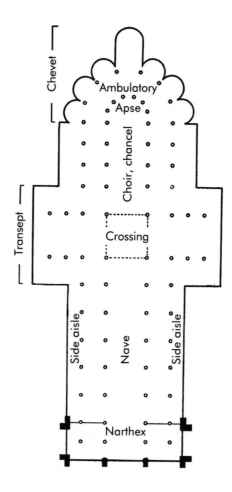

5. Dome

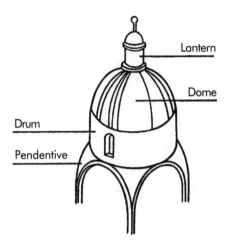

Lantern

Dome

Drum

Pendentive

6. Arcade

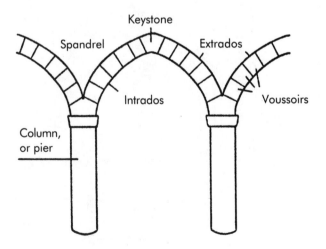

Keystone

Spandrel

Extrados

Intrados

Voussoirs

Column,
or pier

7. Barrel or Tunnel Vault

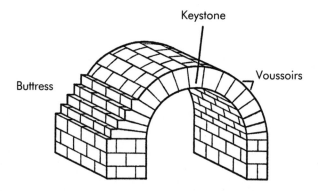

Keystone

Voussoirs

Buttress

8. Groin Vault

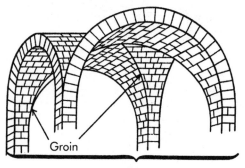

Groin

Bay

9. Gothic Cathedral (interior elevation)

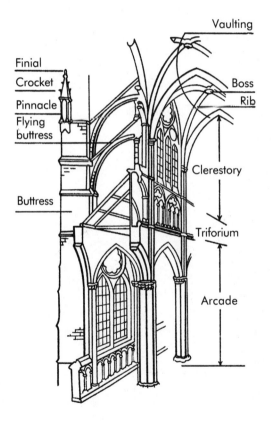

Finial

Crocket

Pinnacle

Flying buttress

Buttress

Vaulting

Boss

Rib

Clerestory

Triforium

Arcade

10. Portal Ensemble (medieval)

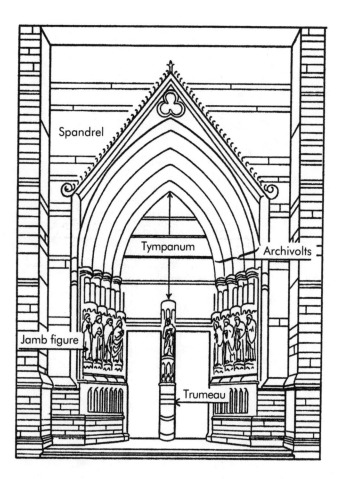

Spandrel

Tympanum

Archivolts

Jamb figure

Trumeau

11. Altar

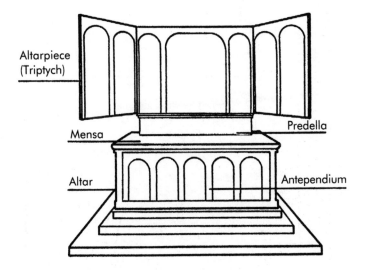

Altarpiece (Triptych)

Mensa

Altar

Predella

Antependium

12. Perspective

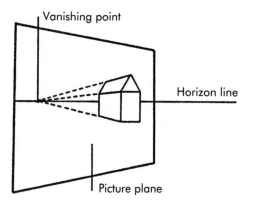

Art
Terms

ABACUS Uppermost element of a CAPITAL. (*Fig. 1*)

ABBOZZO See UNDERPAINTING.

ABSTRACT ART Art in which elements of FORM have been stressed in handling the subject matter—which may or may not be recognizable. Abstraction is a relative term; all artworks exist on a continuum between total abstraction and full REPRESENTATION. Vassily Kandinsky is generally credited with having created the first purely abstract artwork in 1910. See HARD-EDGE PAINTING, CONSTRUCTIVISM, CONCRETE ART, EXPRESSIONISM, NON-OBJECTIVE ART, and MINIMAL ART for examples of abstract art.

ABSTRACT EXPRESSIONISM An umbrella term which refers to that direction in ABSTRACT ART characterized by spontaneous and individual artistic expression in a NON-OBJECTIVE manner. While the term was first applied to certain of Vassily Kandinsky's early experimental paintings, it mostly refers to artists working in the 1940s and 1950s, including Willem de Kooning and Jackson Pollock. Sharing a similar outlook rather than a style, these artists sought total freedom for psychic expression on the canvas. Believed by some to be the first truly American art, the movement is also called the New York school because its international center was New York City. The influence of abstract expressionism extended into the 1970s with LYRICAL ABSTRACTION. See ACTION PAINTING.

ABSTRACTION-CREATION A group of abstract artists gathered in Paris in the 1930s—some of them exiles from Nazi Germany—which attracted representatives of all currents of ABSTRACT ART, from CONSTRUCTIVISM to SUPREMATISM. The group issued an annual periodical by the same name.

ACADEMIC ART Art created in the prevailing styles of European and American art academies. By the late 19th century the AVANT-GARDE looked on academic art as a moribund style being practiced in isolation from current styles—a view now under reconsideration.

ACADEMY Originally, the garden near Athens where Plato taught. Art academies developed in reaction to medieval guilds and became schools for the practical and theoretical training of artists, elevating their status in society. In BAROQUE times they were universities of art, and they continued as powerful arbiters of taste until the end of the 19th century. Rigorous study of the human form and highly structured teaching based on classical standards characterized most academy instruction.

ACANTHUS A stylized acanthus leaf; a much used decorative motif in Greek, Roman, and Renaissance art and architecture.

ACROTERION The ornamental FINIAL placed on the angles of a PEDIMENT in classical architecture or on a STELE. Also refers to an angle of a pediment.

ACRYLIC RESIN PAINT An oil-compatible synthetic MEDIUM which is thinned with linseed oil and turpentine.

ACTION PAINTING Term coined by the American critic Harold Rosenberg to describe the dynamic, impulsive ABSTRACT EXPRESSIONISM of Jackson Pollock.

Emphasizing the unconscious, the method involves applying paint by dribbling, slapping, splashing, or other gestural motions which document energetic physical movement, unplanned and uninhibited by preconceived notions of what the painting will look like. See TACHISME.

ADOBE Sun-dried mud (usually clay) and straw bricks used for building construction. Used since pre-Roman times in Sumerian and Babylonian architecture, adobe has been employed throughout the non-European world, including the U.S. Southwest, and in some European buildings.

ADVANCING COLOR A strong, usually unadulterated warm or hot color (red, orange, or yellow) which appears to come to the fore of a PICTURE PLANE. See RETREATING COLOR.

AEGEAN ART Collective term for the art of a variety of ancient cultures (ca. 2800 B.C. to ca. 1400 B.C.) on the islands and along the coasts of the eastern Mediterranean Sea. The most important were Cycladic, Minoan (on the island of Crete), and Mycenaean (on the coast of mainland Greece).

AERIAL PERSPECTIVE See ATMOSPHERIC PERSPECTIVE.

AESTHETIC MOVEMENT A late-19th-century English movement which advocated a philosophy of ART FOR ART'S SAKE. With a tendency toward affectation, the movement was a reaction against the idea that art must have a purpose. Chiefly a form of art appreciation, its chief apostles were Oscar Wilde, Walter Pater, and James McNeill Whistler. See CAMP.

AESTHETICS Derived from the Greek word meaning to perceive, aesthetics is the philosophy of art. Aesthetic

criticism seeks to formulate nonsubjective laws and criteria to account for human perception of beauty and taste.

AFROCENTRISM A general theory placing the origins of humans on the African continent. Due to its recent dissemination, its effect on art history has been limited so far. Winckelmann's *History of Ancient Art* (1764) is generally recognized as founding the discipline of art history. It emphasizes that the imperfection of ancient Egyptian art was inevitable, due to that culture's lack of beautiful models, a situation contrary to that in which Greek art developed. However, recent evidence that Egyptian deities and ultimately Greek philosophy were partially derived from sub-Saharan cultures will further affect our understanding about the origins of Western art.

"AFTER" In graphic arts, identifies an ENGRAVING, ETCHING, etc., as deliberately copied from an ORIGINAL by another artist and usually in another MEDIUM, though without intent to deceive.

AGITPROP A derogatory term short for agitation propaganda. It is used primarily to describe political art as mere propaganda for the purposes of activist organizing. The term is derived from a Russian expression first employed in the 1930s to describe political education organs of the Central Committee of the Communist party.

AGNUS DEI Symbolic representation of Christ as a lamb with crossed NIMBUS, cross or cross banner, and CHALICE.

AGORA The central marketplace and site of general assembly in Greek and Roman towns, often surrounded by PORTICOES. See FORUM.

ALBUMEN PRINT The most common type of photographic print in the 19th century. COLLODION WET PLATE negatives were printed on papers coated with albumen (egg white) and salt solution, resulting in yellowish prints which were then toned to a sepia color.

ALGRAPHY A PLANOGRAPHIC process employing an aluminum plate instead of a LITHOGRAPHIC stone.

ALL'ANTICA (It., after the antique) Describing works of art done after ancient CLASSICAL models.

ALLA PRIMA (It., the first time) Direct painting. Painting completed at one sitting, essentially a single application of PIGMENTS not relying on UNDERPAINTING for the final effect.

ALLEGORY A series of symbols existing harmoniously in a larger system of meaning. While a symbol most often takes the shape of a letter, word, or image, such as the CROSS as a symbol for Christianity, allegory takes symbolism one step further by using images and/or stories to stand in for other ideas or abstract concepts. Picasso's *Guernica*, rooted in events from the Spanish Civil War, works as an allegory for total war. (Disputed symbols include the wounded horse and the bull, representing Republican Spain and fascism, respectively.) From the mid-1950s to the mid-1970s, the primacy of ABSTRACT ART made the use of allegory seem out of date. But with the advent of POSTMODERNISM and a return to FIGURATIVE and NARRATIVE works, allegory has again flourished. Modernists Giorgio de Chirico, Max Ernst, and José Clemente Orozco make use of allegory, as do postmodernists Anselm Kiefer and Francesco Clemente.

ALTAR A table or similar structure, typically of stone, reserved for religious rites—usually sacrificial. Christian

altars consist of a consecrated stone slab (mensa) on a base. (*Fig. 11*)

ALTAR FRONTAL See ANTEPENDIUM.

ALTARPIECE Decorative painting or sculpture placed above and behind an altar mensa. May consist of one or more parts (shrine, PREDELLA, wings). (*Fig. 11*)

ALTERNATIVE SPACES Not-for-profit "galleries" that flourished in the 1970s as spaces for artists to exhibit their work in a noncommercial setting outside the bounds of the art commodity market. Alternative spaces were important venues for artists' experimental productions involving VIDEO, PERFORMANCE, INSTALLATIONS, and other CONCEPTUAL ART forms. Diversity in MEDIA was paralleled by a diversity in artists represented, with works by women and others of African, Asian, and Latin descent receiving concerted exposure for the first time.

ALTO RILIEVO (It., high relief) Sculpture in high RELIEF, with the design so deeply carved that it approaches detachment from the back plane.

AMBO Early medieval form of pulpit, usually of stone and sometimes decorated with RELIEFS.

AMBULATORY Semicircular processional aisle around the APSE of a church. (*Fig. 4*)

AMERICAN SCENE PAINTING A term that has extended and supplanted the term REGIONALISM. It has come to include several movements from the mid-19th to the mid-20th centuries in which painters chose limited areas or aspects of distinctly American landscape or life as their subjects and rendered them in a direct, usually literal style. Includes the landscapes of Thomas Cole and Albert Bierstadt and the regionalist painters of the Middle West.

AMPHITHEATER A circular or elliptical structure consisting of rising tiers of seats and access corridors around a central open area. Used primarily by the Romans for public games, performances, and gladiatorial contests.

AMPHORA Large, oval-bellied, two-handled vessel used in antiquity to hold wine, oil, etc. Often decorated.

ANALYTIC CUBISM The first phase of CUBISM, from about 1907 to 1912, under the powerful influence of Paul Cézanne, who in 1904 had advised treating nature "in terms of the cylinder, the sphere, and the cone." Analytic cubists reduced natural forms to their basic geometric parts and then tried to reconcile these essentially three-dimensional parts with the two-dimensional PICTURE PLANE. Color was extremely subdued, and paintings were almost uniformly MONOCHROMATIC.

ANAMORPHOSIS The application of certain optical principles to drawing an object, so that it looks normal only when viewed from a certain angle or with a correcting device.

ANCIENT ART Collective term for the art of various cultures in the Mediterranean area from the beginning of history to the end of the Roman Empire: ANCIENT NEAR EASTERN, Egyptian, AEGEAN, Greek, HELLENISTIC, and Roman.

ANCIENT NEAR EASTERN ART Collective term for the art of ancient cultures (ca. 3500 B.C. to ca. 650 A.D.) in Mesopotamia, Iran, and the Levant. Some of the most important were Sumerian (Mesopotamia), Assyrian (Mesopotamia, the Levant), Hittite (Anatolia), and Achaemenian, Parthian, and Sassanian Persian (Iran).

ANCONA An Italian type of large wingless ALTARPIECE made up of many panels.

ANGULAR STYLE Style of northern European painting and sculpture from ca. 1430 to ca. 1530, characterized by complicated rectilinear drapery folds resembling shattered colored glass.

ANIMAL INTERLACE Type of ornament composed of stylized animal forms of which the extremities have been elongated and interwoven. Characteristic of GERMANIC ART and CELTIC ART. Also called lacertine.

ANIMAL STYLE In the broadest sense, ZOOMORPHIC ORNAMENT. Also, a tradition of art arising in the nomadic Scythian (7th century B.C.) and Samartian (5th century B.C.) cultures which found expression in decorative and useful objects ornamented with animal forms and motifs. Animal style is seen in GERMANIC ART and in other cultures as late as the 7th century A.D., reaching its greatest refinement in Scandinavia.

ANTEPENDIUM Covering for the base of an ALTAR, usually of costly textile or precious metal. Also called altar frontal. (*Fig. 11*)

ANTHEMION Flower and leaf design developed in Greek art and used extensively as an ornamental motif in GREEK REVIVAL architecture and on items of EMPIRE design.

ANTI-ART Originally a polemical DADAIST term, it has come to signify creations that critics or the public reject for not being art (e.g., the urinal Marcel Duchamp signed "R. Mutt" and tried, unsuccessfully, to exhibit in New York). Some works are presented by artists as art; some are not intended as art, although they attract attention as anti-art.

ANTIPHONARY Liturgical book containing the texts and music of prayers offered at mass and divine office.

APPLIED ARTS A broad class of utilitarian objects made with aesthetic considerations as an important part of their design and execution. This includes works of CERAMIC, furniture, glass, leather, metalwork, and many items of textile art, arms and armor, clocks and watches, jewelry, musical instruments, and toys. See DECORATIVE ARTS, "LOW" ART.

APPLIQUÉ A type of embroidery in which shaped pieces of fabric or other material are stitched to a fabric GROUND to form designs. Less often the term refers to applied decoration on leather, silver work, etc. Also called applied work.

APPROPRIATION/REAPPROPRIATION A strategy or technique that has its theoretical origins in POSTMODERN criticism. In its simplest form, an artist may simply "steal" another's preexisting image and sign it as his/her own, as Sherrie Levine has done with Walker Evans's photographs. Appropriation blurs the line between FAKES and ORIGINALS. Reappropriation connotes "stealing" an image, symbol, or statement from outside the realm of art. In the mid-1980s the ART COLLECTIVE Gran Fury reappropriated the pink triangle for the purposes of AIDS activism. Once the symbol of Nazi oppression against gays and lesbians, it was now used in conjunction with the slogan "Silence = Death." In turn, the antiabortion movement has since appropriated the slogan "Silence = Death." See ORIGINAL, ORIGINALITY, AUTHENTICITY.

APSE Vaulted semicircular or polygonal space at the end of an aisle, a CHAPEL, or the CHANCEL of a church. (*Figs. 3, 4*)

AQUAMANILE Medieval liturgical vessel, usually of bronze or brass in the form of a symbolic animal, used to receive holy water for the washing of the priest's hands during the mass.

AQUARELLE A painting executed with transparent WATERCOLOR WASHES.

AQUATINT An ETCHING process in which a mordant acid is made to bite both lines and tonal areas in the copper plate. An aquatint resembles a WATERCOLOR in its tonal effects.

ARABESQUE Surface decoration of rhythmic, fancifully intertwined LINEAR patterns of flowers, leaves, scrollwork, etc.

ARCADE A row of ARCHES on COLUMNS or PIERS. Also, an arched, covered GALLERY or passageway. (*Figs. 6, 9*) Compare BLIND ARCADE.

ARCH A curved construction for spanning an opening: doorway, window, portal, etc. The shape of the curve may take many forms. A masonry arch is formed of wedge-shaped VOUSSOIRS locked in place by a KEYSTONE.

ARCHAIC, ARCHAISM, ARCHAICISM Strictly, these words refer to certain styles of ancient art, but they are also applied to any work that retains the spirit of or elements from ancient art. Loosely applied, they refer to a work of art that is old-fashioned in comparison to contemporaneous movements. Also called RETARDATAIRE.

ARCHITECTONIC Relating to the use of architectural principles as an element in DESIGN.

ARCHITRAVE The lowest section of an ENTABLATURE, resting directly on the topmost element of a COLUMN. Also,

the MOLDINGS surrounding a doorway, window, or the outside of an ARCH. (*Fig. 1*)

ARCHIVOLT Continuous MOLDING framing the face of an arch. In medieval architecture it was often decorated with sculpture. (*Fig. 10*)

ARMATURE Rigid framework, usually of metal, made by a sculptor as a foundation or "skeleton" to which clay or another moldable substance is applied.

ARMORY SHOW Popular name for the International Exhibition of Modern Art held in New York City's 69th Regiment Armory building in 1913. Regarded as profoundly influential for American art because of its large-scale exposure of AVANT-GARDE European and American painters and sculptors.

ARRICCIO (It., wrinkle) In the preparation of a wall for FRESCO, the second coat of plaster, over the ROUGHCAST and under the INTONACO.

ART BRUT A term coined by French artist Jean Dubuffet to characterize spontaneous and rough artistic expressions of children, prisoners, and the insane. Dubuffet's collection of art brut inspired him to reclaim untrained and marginal artistic elements in his own work. See NAIVE ART and "OUTSIDER " ART.

ART COLLECTIVE OR **COLLABORATION** Two or more artists who work together to produce artworks. Many artists reacting against the art market's emphasis on the individual artist as "master" sought to create work which could be ascribed not to just one artist, but rather to the collective. Members of the Guerrilla Girls, a collective of women artists working against sexism in art institutions, never appear

publicly without wearing gorilla masks to protect their anonymity.

ART DECO A style of the 1920s and 1930s seen in architecture, APPLIED ARTS, interior design, and graphic design which combines some highly decorative elements of late ART NOUVEAU with streamlined geometric forms inspired by current industrial design.

ART FOR ART'S SAKE From the French, "l'art pour l'art," the notion that art can and should exist for itself alone, totally free of society's influence and especially of bourgeois tastes. Gained currency in the 1840s and became the watchword of the AESTHETIC MOVEMENT.

L'ART INFORMEL Term coined by French critic Michel Tapié to describe the European counterpart to American ABSTRACT EXPRESSIONISM and specifically ACTION PAINTING.

ART NOUVEAU A style of decoration that found expression in architecture and items of interior design, illustration, and dress. Highly stylized, organically flowing plant forms are the most common design motifs of art nouveau, which was chiefly an American and European movement that crested in popularity between 1895 and 1905. It was known by various names in different countries: JUGENDSTIL in Germany, "stile liberty" in Italy, "modernisme" in Spain. In America the term "modern style" was current.

ART THERAPY The practice of free-expression painting, modeling, etc., as a curative activity by individuals with mental disorders or by others for psychomedical reasons.

ARTE POVERA Literally translated as "poor art," the term was coined by the Italian critic Germano Celant in

1967. Through solid grounding in the use of
materials such as twigs, newspapers, and soil,
arte povera artists sought to make metaphorical
statements about nature, culture, history, and con-
temporary life while also diminishing the commer-
cial viability of their works. Artists working in the
style include Mario Merz and Giulio Paolini.

ARTIFACT In archaeology, a product of prehistoric workman-
ship, as distinct from a useful natural object.
Occasionally used when referring to a rudimen-
tary art form or art object.

ARTIST'S PROOF A PRINT made for the artist's personal use,
designated as such, and not part of the EDITION of
that print.

ARTS AND CRAFTS MOVEMENT An English-based movement
begun about 1850 and dominated by the theories
of William Morris. It strove to raise the artistic
level of industrial design and to integrate high
aesthetic principles with fine workmanship.

ASHCAN SCHOOL A group of American realist painters, some
of them former illustrators, who evolved from THE
EIGHT about 1908, and who drew upon unideal-
ized facets of urban life for subject matter.

ASHLAR Stone blocks hewn to an accurate square and hav-
ing a smooth face. Also, masonry of such stone
laid evenly. See RUSTICATION.

ASSEMBLAGE Comparable to COLLAGE, this three-dimensional
art form was described by William Seitz in 1961
as "predominantly assembled, rather than
painted, drawn, modeled, or carved. . . . Entirely,
or in part, its constituent elements are pre-formed
natural or manufactured materials, objects, or
fragments not intended as art material." Includes
CUBIST PAPIERS COLLÉS, photomontage, JUNK SCULP-

TURE, even room environments. This type of sculpture moves away from the use of traditional FINE ART materials such as stone and bronze and may result in ABSTRACT or REPRESENTATIONAL works. Louise Bourgeois and Edward Kienholz work in this technique.

ATELIER A WORKSHOP; an artist's studio. The atelier libre, for which one pays a fee, provides facilities and a model, but not instruction.

ATLANTES Partly or fully nude muscular male figures of stone used as ENTABLATURE bearers. Atlantes is the plural of Atlas, the mythological Greek Titan who was condemned to holding up the heavens with his head and hands. CARYATID is the female counterpart.

ATMOSPHERIC PERSPECTIVE The effect of distance in a painting created by using paler and less intense colors for faraway elements, representing them as they appear in nature owing to conditions of distance, air, and light. Also called aerial perspective and color perspective.

ATRIUM An open central court in Greek and Roman houses. In Early Christian churches, a forecourt surrounded by COLUMNS; later called the vestibule. (*Fig. 3*)

ATTRIBUTE Object-symbol used to identify the figure with whom it is shown, e.g., an instrument of martyrdom with the representation of a saint, such as arrows and Saint Sebastian.

"ATTRIBUTED TO" In describing a work of art, it indicates a degree of uncertainty about whether the artist named executed the work.

AUREOLE The indication of a circle of light (GLORY) around the head or body of a sacred personage in art. Halo and NIMBUS refer to such light around the head, MANDORLA when it surrounds the entire body.

AUTHENTICITY An issue that most frequently concerns non-Western art or so-called "PRIMITIVE ART." For a work to be representative of its culture, it must be ORIGINAL to an insular context where life-style and rituals are unaffected by the Western world. Additionally, it must bear no relationship to the art market (i.e., it cannot have been produced for sale as a work of art). This term has come under much criticism as anthropological notions about culture continue to change. Western artworks that are not FAKES or COPIES are considered authentic.

AUTHORSHIP At the heart of MODERN ART values is the question of authorship—who created this work and/or to whom can we attribute it? The idea of the individual artist who, as a genius, creates an entire OEUVRE of original work is firmly planted within the art world. This works to the advantage of galleries and museums, which organize exhibitions around single artists whose works then increase in price. This valorization of the individual is under increasing scrutiny by artists who organize as ART COLLECTIVES and by POSTMODERNIST critics.

AUTOMATA Class of art objects animated by mechanical means, such as clocks with moving figures which strike chimes or revolving models of the planetary system.

AUTOMATISM In SURREALISM, the practice of automatic drawing or painting or writing. Governed by unconscious free association, the artist works with uncontrolled movements of the hand, pencil, or brush. Artists who used this method include Joan Miró and André Masson.

AVANT-GARDE Traditionally understood as those artists or works that are ahead of their time. MODERNISTS were deeply invested in the idea of an "advance guard" that pushed ahead of bourgeois tastes and trends. While many modern works may still be difficult to comprehend, the idea that artists can create works unaffected by time or context has been discredited by many art historians. The recent proliferation of STYLES and movements in contemporary art is, in part, a response to quick COMMODIFICATION. Art has since appeared faddish, making the notion of a current avant-garde problematic.

AZULEJOS The Spanish word for CERAMIC tiles used for decorative purposes to embellish architecture. The art is a legacy from the Arab occupation of the Iberian peninsula, and fine examples are found in both Spain and Portugal.

B

BALDACHIN, BALDACCHINO A canopy, usually supported by four COLUMNS and often placed over an ALTAR, particularly in the BAROQUE churches. Before the baroque period, such an altar canopy is called a CIBORIUM.

BALLOON FRAME Method of timber construction developed by an American in the mid-19th century to enable fast, cheap building. Wall studs run from the first floor sills to the eaves, with the horizontal members attached to the upright studs. At first derided for its seeming fragility, the balloon frame is now used in most residential frame construction.

BALUSTRADE Series of PILLARS (balusters) supporting a rail to form a low wall or parapet.

BAMBOCCIADE (It., bambocciata) Representation of a GROTESQUE scene from rustic or peasant life made popular by Dutch and Flemish artists in Italy in the 17th century. Derived from "Il Bamboccio," nickname of Pieter van Laer, the 17th-century Dutch artist noted for such subjects.

BAPTISTERY Place where the rite of baptism is performed. In the Early Christian period the baptistery was a separate building, often octagonal in shape. In the Middle Ages the baptistery was incorporated within the church.

BARBARIC ART See GERMANIC ART.

BARBIZON SCHOOL A group of NATURALIST painters, mostly French, who gathered at the village of Barbizon on the outskirts of the Forest of Fontainebleau from the 1830s through the 1860s. Most were landscape painters committed to portraying nature as a worthwhile subject in its own right. Théodore Rousseau was the founder of the group. Others among them were Jean-Baptiste Corot, Jean-François Millet, and Charles Daubigny. Their approach presaged IMPRESSIONISM.

BAROQUE ART Western European art from ca. 1580 to ca. 1720. First developed in Italy, especially in Rome, inspired by the Counter-Reformation. It displayed great interest in dynamic movement, grand and often theatrical effects, and elaborate ornamentation. The fusion of architecture, sculpture, and painting into an elaborate total work of art was perhaps the outstanding achievement of baroque art.

BARREL VAULT The simplest form of VAULTING, consisting of a continuous row of ARCHES. Utilized in Roman architecture, it was the mainstay of ROMANESQUE church construction. Also called tunnel vault. (*Fig. 7*)

BASILICA Originally a Roman building type, it became the basis for the Christian church. It is rectangular in PLAN with the interior divided into three aisles by two rows of COLUMNS. The center aisle (NAVE) is higher than the SIDE AISLES, allowing for a row of windows (CLERESTORY). (*Fig. 3*)

BAS-RELIEF (It., basso rilievo) Sculpture in low RELIEF.

BAUHAUS A center for research and the teaching of architecture, art, and industrial design founded in Weimar, Germany, in 1919 by Walter Gropius and subsequently located in Dessau until closed by Hitler in 1933. The Bauhaus advocated com-

plete integration of art and technology in the FINE ARTS, APPLIED ARTS, and the practice of architecture. See INTERNATIONAL STYLE.

BAY Space in an interior formed by supporting structural members of walls and/or ceiling; e.g., the bays of a church are formed by COLUMNS of an ARCADE and the RIBS of the VAULTING (*Fig. 8*). Also, external articulation of the structure of a building, marked by FENESTRATION or BUTTRESSES.

BEARING WALL Any wall that supports part of the weight of a structure, as distinguished from a nonsupporting CURTAIN WALL.

BEAU DIEU, LE (Fr., the beautiful God) A GOTHIC typological representation of Christ as a benevolent teacher. The most famous example is a TRUMEAU figure on Amiens Cathedral.

BEAUX ARTS Describing a movement that found expression in a NEOCLASSICAL style of late-19th and early-20th-century architecture. Derived from the inspiration and designs of the great European ACADEMIES, notably the École des Beaux Arts, buildings are large and exuberant expressions of enthusiasm for CLASSICAL motifs. Sometimes called beaux arts classicism.

BELVEDERE Small structure, usually surmounting a roof, which commands a view. A belvedere must have open sides, while a CUPOLA can be windowless.

BESTIARY A collection of moralized fables often about actual or mythological animals and usually written in the Middle Ages. When collected together in books, bestiaries are often elaborately decorated with ILLUMINATIONS.

BÉTON BRUT "Raw concrete" is the result of pouring wet cement into a temporary form made of timber or metal. When the cement dries the form's texture remains imprinted upon the surface. It is an important element in the work of Le Corbusier. See BRUTALISM.

BIBELOT (Fr., trinket, knickknack) Small art object made for personal use or for decoration. Compare OBJET D'ART.

BIBLIA PAUPERUM Literally, Bible of the poor. Book, either MANUSCRIPT or printed, of the late Middle Ages containing juxtaposed scenes from the Old and New Testaments.

BIEDERMEIER The German and Austrian form of EMPIRE STYLE, ca. 1815–1848, especially in furniture and articles of interior decoration. Extended to those paintings of the ROMANTIC period that depict subjects favored by the middle class. The term is not applicable to architecture or sculpture.

BISCUIT Unglazed PORCELAIN or POTTERY. Also called bisque.

BISQUE See BISCUIT.

BISTRE, BISTER An impermanent brown PIGMENT prepared from soot. Used since the late Middle Ages as a MONOCHROMATIC WASH for drawings and in WATERCOLOR painting.

BITUMEN Mineral pitch, asphaltum. When used as a PIGMENT, it causes severe cracking. Has poor drying properties and tends to soften in heat.

BLACK-FIGURE VASE PAINTING Technique and style of decorating ancient Greek CERAMIC WARE. The design was painted in black GLAZE directly on the clay, which

was usually reddish-brown. Inner details were drawn by scratching (incising) through the black glaze. Chiefly associated with vessels of the 6th century B.C.

BLAUE REITER, DER (Ger., the blue horseman) A group of Munich-based artists, including EXPRESSIONISTS, CUBISTS, ORPHISTS, and ABSTRACT painters, who came together in 1911, founded by Vassily Kandinsky and Franz Marc. Members of the group shared an interest in expressing spiritual values through their art.

BLEEDING THROUGH The gradual visibility of underlayers of paint caused when oil-based PIGMENTS of the upper layers become transparent with the passage of time.

BLIND ARCADE, BLIND TRACERY An ARCADE or TRACERY applied against a solid wall or other unpierced surface. Commonly used in late GOTHIC architecture and furniture.

BLOCK BOOK Early form of book in which both text and illustrations for each page were cut from a single block of wood. Produced in Germany and the Netherlands in the 15th century.

BODY ART A trend of PERFORMANCE ART and a variation on HAPPENINGS, in which an artist's body or that of another person is used as the MEDIUM for the work. Ana Mendieta and Vito Acconci are among the artists known for their practice of body art.

BODY COLORS PIGMENTS that possess "body," or opacity, in contrast with transparent pigments.

BOISERIE (Fr., wainscot) Elaborately carved woodwork and paneling associated especially with French interiors of the 17th and 18th centuries.

BONE CHINA Type of translucent PORCELAIN containing bone ash. Developed in England.

BOOK OF HOURS Late medieval book containing hourly prayers for private devotions. Often sumptuously decorated with ILLUMINATIONS.

BOSS A protuberant ornament, especially on carved or modeled OBJETS D'ART such as metalwork and POTTERY. In architecture, the stone projection, or block, at the intersection of vaulting RIBS or GROINS. Often carved with GROTESQUE portraits, symbols, or designs. (*Fig. 9*)

BOULLE (BOULE, BUHL) Ornamental furniture inlay of silver, brass, mother-of-pearl, tortoiseshell, etc., invented in the late 17th century by André Boulle, a French cabinetmaker.

BOZZETTO A small model, often of terra-cotta, made by a sculptor as a trial sketch for a larger work of sculpture. Also called Maquette.

BRACKET A supporting architectural brace for an overhanging eave, shelf, window cap, etc.; it arcs the space from vertical side to horizontal overhang. Since ancient times, brackets have been carved and ornamented. Compare CORBEL.

BRAZE To join pieces of metal with a high-melting-point solder such as copper, zinc, or brass. Often used in modern sculpture.

BREVIARY Book containing all the daily public hymns, prayers, lessons, etc., for the canonical hours.

BRISE-SOLEIL (Fr., sun-break) An architectural structure designed to shade large glass windows from the sun in summer. Le Corbusier used them extensively in his building designs in India, Brazil, and

Marseilles. Their inclusion is now standard practice in modern architecture of tropical climates.

BRITANNIA WARE Objects made of Britannia metal, an alloy similar to pewter and developed in Britain around 1800. Usually cheaper than pewter because it was manufactured by spinning, stamping, and rolling rather than by casting and turning.

BRONZE DISEASE Light green spots that disfigure ancient bronzes, caused by salts which have impregnated the surface of the metal while the objects were buried. Spreads if not properly treated.

BRÜCKE, DIE (Ger., the bridge) A group of German EXPRESSIONIST painters associating in Dresden about 1905. The name was chosen as a metaphor for their art, which they intended to serve as a bridge to the art of the future. The counterpart to LES FAUVES, Die Brücke painted subjects from street life, landscapes, nudes, and carnival people in strong colors and broad forms with hard outlines. They also revived the German WOODCUT tradition. Chiefly associated with Die Brücke were Ludwig Kirchner, Karl Schmidt-Rottluff, Fritz Bleyl, and Erich Heckel.

BRUSH DRAWING Drawing executed entirely with brush and usually in a WASH. The favored technique of oriental painting.

BRUTALISM A term coined by the British to characterize the style of Le Corbusier in the early 1950s and others inspired by him. His buildings at Marseilles, France, and Chandigarh, India, make use of BÉTON BRUT. Increasingly preoccupied with sculptural effects, brutalist architects moved away from the geometric purism of the INTERNATIONAL STYLE.

BUCRANIA Ornament of ox skulls wreathed with garlands, used in classical and post-Renaissance art.

BURIN A metal tool, usually with an oblique point and rounded, knoblike handle, used in ENGRAVING metal plates and carving stone. Also called graver.

BURR The ridge of metal plowed up by the BURIN, or graver, in the process of engraving a copper plate. In a LINE ENGRAVING the burr is removed to produce a clean line; in DRYPOINT it is not removed, in order to produce a soft effect.

BUTTRESS A projecting, reinforced section of a wall, usually on the outside of a building and opposite a major point of stress. (*Figs. 7, 9*) See FLYING BUTTRESS.

BYZANTINE ART Art of the Eastern (Greek) Empire called Byzantium, with its capital at Constantinople. First seen in the 5th century, its initial highpoint was in the reign of Justinian in the early 6th century; it lasted until the mid-15th century and the destruction of the Empire by the Turks. At times it exhibits strongly stylized or HIERATIC qualities owing to important oriental components. At other times classical REALISM from Greek art appeared in the style. Western art shows Byzantine influences in certain periods: the hieratic style in OTTONIAN ART, and Byzantine classicism in some French GOTHIC ART of ca. 1200.

CABINET PICTURE See EASEL PICTURE.

CABOCHON A convex oval or round element of decoration, especially as used on furniture and works of gold- and silversmithery. Also, an unfaceted, highly polished gemstone of that form.

CALLIGRAPHIC See CALLIGRAPHY.

CALLIGRAPHY Fine or elegant handwriting. When a drawing is described as calligraphic, it is LINEAR, with flowing, rhythmic strokes and a distinctively personal quality.

CALOTYPE Early photographic process; the first to employ a negative to produce a positive image on paper. Patented by William Henry Fox Talbot in 1840 and supplanted in 1851 by the COLLODION WET PLATE process. Calotype prints are usually brown. Also called Talbotype.

CAMAIEU, EN (Fr., as a cameo) Painting in MONOCHROME. When in gray tones, a painting is called GRISAILLE; when in yellow, cirage.

CAMERA LUCIDA A 19th-century development of the CAMERA OBSCURA, employing a prism to project an image onto the drawing surface.

CAMERA OBSCURA A device that uses a lens to throw a reduced image of natural objects onto a flat surface.

CAMP The camp vision promotes a new set of standards antithetical to high culture's valorization of truth, beauty, and seriousness. Rather, it is a sensibility encompassing an ironic appreciation for that which is considered artificial and exaggerated. Manifestations of camp taste include revival interest in movies, 1950s furniture design, 1960s fashions, cross dressing, and drag cultures. The sentimental embrace of past and even contemporary styles, fads, and vogues of POPULAR CULTURE provided the basis for POP ARTISTS' inclusion of mass-produced images and/or objects in their work. See KITSCH.

CAMPANILE In Italian architecture, a freestanding bell tower.

CANON (of art history) That well-known body of individual artists and works which, until recently, was accepted as universal art made by masters. These artists exemplified the best of the Western tradition in aesthetic beauty in three fields: painting, sculpture, and architecture. This definition and narrow focus are being challenged by art historians recovering forgotten and ignored artists (see FEMINISM) both within and outside the Western world. Likewise, the scope of art is being widened considerably as new fields, including CRAFT, photography, VIDEO, and DESIGN, are added to an ever-increasing canon.

CANOPIC JAR A jar used in ancient Egypt to contain viscera from an embalmed body. Often decorated.

CAPITAL The head of a PILLAR or COLUMN, directly surmounting the shaft and directly beneath the ENTABLATURE. It normally consists of several elements, e.g., the

ABACUS and ECHINUS in the Greek Doric order. (*Fig. 1*)

CAPRICCIO A picture in which accurately rendered buildings or other architectural structures are grouped in an arbitrary, imaginary arrangement. Some of the VEDUTA painters, such as Antonio Canaletto, specialized in capricci.

CARICATURE A representation of a person or thing in which the characteristic features are exaggerated, generally for the purpose of satire or humor. To some degree, caricature is practiced in most portraiture.

CAROLINGIAN ART European art from the end of the 8th century to the beginning of the 10th century. Initiated by Charlemagne as the first Holy Roman emperor, Carolingian art shows conscious emulation of ancient CLASSICAL art. Carolingian artists of Germanic heritage instilled a new organic vigor into classical models and thus laid the foundation for medieval art.

CARTOON A preliminary drawing in full size used as a model for a painting, MURAL, tapestry, MOSAIC, STAINED GLASS, etc. Also, a CARICATURE or comic drawing, or an animated film composed of a series of comic drawings.

CARTOUCHE An ornamental frame — painted, sculptured, ENGRAVED, or printed — designed to contain an inscription or decoration. Also, the oval frame enclosing the name of an ancient Egyptian sovereign.

CARYATID Statue of a draped woman placed to support an ENTABLATURE. See also ATLANTES.

CASSONE (It., chest) Traditionally, an Italian marriage, or "hope," chest. By the 15th century, many were

richly ornamented with intricate carving and painted side and front panels (cassone painting).

CASTING In sculpture, the process of duplicating the original wax or clay model in metal, plaster of Paris, or other material by means of a mold. See CIRE PERDUE.

CATACOMB A subterranean burial place, usually with accommodation for a number of tombs. Some catacombs that were the burial places of the early Christians in Rome are decorated with symbolic wall paintings.

CATALOGUE RAISONNÉ In addition to being a MONOGRAPH, the catalogue raisonné attempts a complete description of an artist's works, including details of PROVENANCE, autograph quality, and condition.

CATHEDRA (Lat., chair) Term used both figuratively and actually to designate the chair of a bishop.

CAVE PAINTING See PREHISTORIC ART.

CAVO RILIEVO (It., sunken relief) Hollow RELIEF, or INTAGLIO, in which the design is cut into the surface instead of standing out from it.

CELADON Chinese or Japanese PORCELAIN ware which has a grayish or greenish GLAZE.

CELLA The enclosed, roofed chamber that housed the cult image in a Greek or Roman temple. (*FIG. 2*)

CELTIC ART Art of the ancient and early medieval Celtic peoples in Europe and the British Isles. There were two main phases: early Celtic, produced in western Europe during the La Tène period (ca. 450 B.C. to the birth of Christ); and later Celtic, pro-

duced chiefly in the British Isles from ca. 150 to ca. 650 A.D. Celtic art lingered in Irish art of the early Middle Ages (650 to 1150 A.D.).

CERA COLLA (It., wax glue) An emulsion of wax and glue water, used by Byzantine artists and Italian PRIMITIVES for TEMPERA PAINTING.

CERAMIC WARE Technically, all products made by shaping and firing clay. Besides the major categories of utilitarian and ornamental ceramic wares (including PORCELAIN, STONEWARE, EARTHENWARE, TERRACOTTA, and tiles) there are numerous specialized ceramics.

CEROGRAPHY ENCAUSTIC painting. Also, any sort of painting on wax.

CHALICE Liturgical vessel in the form of a cup, made of precious metal and often highly decorated. It is used to contain the consecrated wine during mass.

CHAMFER An oblique face or bevel cut at the corner of a board. Also, to cut grooves and FLUTING or a beveled edge.

CHAMPLEVÉ ENAMEL A method of decorating metal, usually copper, by hollowing out parts of the background, filling the depressions with colored, vitreous glass pastes (ENAMELS), and firing until the pastes fuse to the metal. The process was favored by the Celts and Romans and by Germanic artists; it reached its peak in the enamelwork of the 11th to 14th centuries. Compare CLOISONNÉ.

CHANCEL Strictly, that section of the east end of a church where the high ALTAR is located. More generally, the east end of a church up to the CROSSING. (*Fig. 4*)

CHAPEL A small church; also, a space within a large church that contains an ALTAR. See also RADIATING CHAPEL.

CHAPTER HOUSE Structure or room set aside for meetings of the governing body of a CLOISTER or bishopric. English GOTHIC chapter houses are octagonal rooms with particularly complex VAULTING and richly painted decoration.

CHASING A method of ornamenting metal surfaces by EMBOSSING, hollowing, or ENGRAVING with steel tools. Also, the finishing of bronze casts by removing small imperfections and smoothing rough spots.

CHEVET The east end of a church, consisting of APSE, AMBULATORY, and radiating CHAPELS. (*Fig. 4*)

CHIAROSCURO The treatment of light and shade in painting. Those 17th-century painters, such as Rembrandt and Caravaggio, who painted in strongly contrasting tones are especially identified with chiaroscuro. Also, an early line block WOODCUT printed in several colors. Compare SFUMATO; see TENEBRISTS.

CHINA Loosely used term for better quality CERAMIC WARE, like PORCELAIN, in contrast with less refined wares, such as POTTERY.

CHINOISERIE French term for a style of decoration based on pseudo-Chinese motifs associated especially with ROCOCO furniture, CERAMICS, and interior design. It arose in the 17th century and peaked in popularity about 1750. Chinoiserie was particularly favored in France, Holland, Germany, and Great Britain.

CHOIR Section of a church where sacral rites are performed. In a cruciform church, between APSE and CROSSING. (*Fig. 4*)

CHROMOLITHOGRAPHY The technique of making multicolor
LITHOGRAPHS by using a different stone or plate for
each color of ink.

CHURRIGUERESQUE A 17th-century Spanish architectural style
named after the Churriguera family of architects
and designers. The influence of sculpture most
characterizes the style, as structural elements
become mere props for ornament. While the style
predominates in Castile, the term often refers to
the florid late BAROQUE architecture of Spain and
Latin America.

CIBORIUM A canopy, or BALDACHIN, over an ALTAR. Also, a
liturgical vessel used to hold the consecrated host.

CINQUECENTO (It., five hundred) The 16th century, used espe-
cially when referring to Italian art and literature of
that century.

"CIRCLE OF" In attributing a work of art, it denotes the influ-
ence of the artist named on the style of the work
and implies a shared geographic origin and close
dates. Compare "FOLLOWER OF," "MANNER OF,"
SCHOOL, WORKSHOP.

CIRE PERDUE (Fr., lost wax) A CASTING process using a wax
model which is encased in a molding material
(such as sand or plaster), then melted away, leav-
ing a hollow mold for the metal cast. The method
may be used to produce a hollow metal cast by
applying a thin coating of wax over a clay core
and then encasing the waxed core in plaster.
When the wax is melted by heating, a thin space
remains into which the molten metal is poured.

CLASSICAL ABSTRACTION The exercise of rigorous intellectual
discipline and technical control in ABSTRACT paint-
ing and sculpture, as in the art of Piet Mondrian,

Kazimir Malevich, Ben Nicholson, and Barbara Hepworth. Compare ABSTRACT EXPRESSIONISM.

CLASSICAL ORDER One of five main classical architectural types (Doric, Ionic, Corinthian, composite, and Tuscan) based on the form and arrangement of a COLUMN with base (except Doric), shaft, CAPITAL, and ENTABLATURE. The first three were Greek inventions; the last two were Roman. (*Fig. 1*)

CLASSICISM In the broadest artistic sense, art based on the study of classical models; art that emphasizes qualities considered to be characteristically Greek and Roman in style and spirit, i.e., reason, objectivity, discipline, restraint, order, harmony.

CLAUDE GLASS A black convex glass that reflects a view in miniature while eliminating color and small details. Said to have been used by Claude Lorrain in the 17th century, it assists in the selection of landscape subject matter and permits the artist to see a scene as a unity. See REDUCING GLASS.

CLERESTORY Row of windows above the ARCADE in the NAVE of a church. (*Fig. 9*)

CLOISONNÉ ENAMEL A technique of ENAMELING in which the design is laid down in thin metal strips on a metal or PORCELAIN ground, forming chambers (cloisons) to receive the vitreous enamel pastes. It was the enameling method favored and possibly developed by the BYZANTINES, with the best examples dating before the 11th century. Compare CHAMPLEVÉ.

CLOISTER An enclosed quadrangle or open courtyard surrounded by an open ARCADE or COLONNADE. Often providing roofed or VAULTED passages around a garden, it connects the monastic church with the domestic parts of the monastery.

COBRA GROUP A movement lasting from 1948 to 1951 which was composed of Dutch, Danish, and Belgian artists who represented a more powerful, northern EXPRESSIONISM in opposition to the polished ABSTRACTION of the school of Paris. Asger Jorn, Karl Appel, and Corneille were among the founding members. The name is an acronym of Copenhagen, Brussels, and Amsterdam.

CODEX Book with the text handwritten on separate leaves; a MANUSCRIPT book. Codices of parchment and vellum are known from the 4th century A.D., when the transition from a rolled scroll form took place. A machine-printed book is not a codex.

COFFER A panel recessed into the surface of a VAULT, ceiling, or DOME. Also, a chest for valuables.

COIN SILVER Silver alloy containing about 900 parts silver and 100 parts base metal, as contrasted with sterling, which is 925 parts silver.

COLLAGE The use of paper and other basically flat "useful" materials (such as cardboard, fabric, string, newspaper clippings, and photographs) to form a picture or DESIGN. Explored by the DADAISTS and SURREALISTS, the technique was an outgrowth of the PAPIERS COLLÉS of the CUBISTS.

COLLODION WET PLATE An early photographic process in which the negative was a thick glass plate coated with emulsion and exposed while still wet. Although awkward, it was the standard method of making negatives between its invention in 1851 and the widespread adoption of the GELATIN DRY PLATE process in the 1870s. Also called wet plate and wet collodion process.

COLLOGRAPH A PRINT pulled from a block on which the DESIGN is made by built-up COLLAGE-like layers of material.

COLLOTYPE Photomechanical reproduction process used when exceedingly fine detail is desired. Introduced for commercial use in 1868 by Joseph Albert.

COLONETTE A tall slender COLUMN.

COLONNADE A row of regularly spaced COLUMNS supporting an ENTABLATURE.

COLOR Color has three attributes: 1. hue or tint—the actual color itself, e.g., red. 2. intensity—the degree of purity, strength, or saturation. 3. value—the lightness or darkness of a color; the amount of light reflected or transmitted by a colored object.

COLOR-FIELD PAINTING As exemplified by the paintings of Barnett Newman and Mark Rothko, color-field painting has solid areas of color painted to the edge of the canvas and by suggestion beyond the canvas to infinity. Most paintings in this mode are large and are intended to be seen close up in order to envelop the viewer completely in a color environment. Compare SYSTEMIC PAINTING, HARD-EDGE PAINTING.

COLOR PERSPECTIVE See ATMOSPHERIC PERSPECTIVE.

COLORED GRAY A gray resulting from mixing COMPLEMENTARY COLORS, such as red and green or blue and orange.

COLUMN A tapering cylindrical PILLAR normally used to support another architectural member, but also occurring alone as a monument. Consists of a base (usually), a shaft, and a CAPITAL. (*Figs. 1, 6*)

COLUMN FIGURE See JAMB FIGURE.

COMMODIFICATION A term derived from MARXIST analyses of the social forces that guide the production and

sale of products, or commodities. Since the RENAISSANCE, artworks have been commodities paid for by religious or royal patrons. By the 20th century, art production had become entangled in a complex economic web composed of collectors, auction houses, galleries, and museums. In the tradition of DADA, 1960s artists feeling constrained by increasing commercialism sought to create unmarketable works, giving rise to CONCEPTUAL, political, PERFORMANCE, and EARTH ART. Recent artists concerned with issues of ORIGINALITY, AUTHORSHIP, and CAMP are indirectly addressing issues of commodification and CANON formation.

COMPLEMENTARY COLOR A color having maximum contrast with another color. The complementary of a PRIMARY COLOR is formed by mixing the other two primary colors. Thus green is the complementary of red.

COMPOSITE CAPITAL A CAPITAL containing elements from both Ionic and Corinthian orders. See CLASSICAL ORDER.

COMPOSITION The organization of FORM in a work of art, i.e., the disposition of shapes, masses, areas of light and dark, etc.

CONCEPTUAL ART Ideas presented by artists not as tangible, visually formed objects, but through other stimuli for creating a mental image: photographs, specifications, formulas, videotapes, speech, and language itself. Emerging in the 1960s with such artists and theorists as Joseph Kosuth and Allan Kaprow, conceptual art had its origins in Marcel Duchamp's READY-MADES, for which thinking rather than manipulation of materials was made primary. The term has come to include examples from PERFORMANCE and VIDEO ART.

CONCH Semi-DOME of an APSE or similar half-circular space.

CONCRETE ART Term coined in 1930 to describe the geometric abstractions of Theo van Doesburg, Piet Mondrian, Kazimir Malevich, and DE STIJL that had been created in the 1920s. Concrete art is now seen as art concerned with controlled organization in both the creative process and in the work of art. COLOR-FIELD PAINTING, SYSTEMIC PAINTING, and OP ART are among the descendants of concrete art.

CONCRETE POETRY See LETTRISM.

CONSERVATION See RESTORATION.

CONSTRUCTIVISM The creation of three-dimensional abstractions from materials used in modern technics, e.g., wire, iron, plastic, glass, wood. The first constructivist exhibition took place in Moscow in 1920. With its emphasis on rationality and modern technology, constructivist sculpture focused on space rather than mass. Begun as a Russian ABSTRACT style, it is sometimes called Tatlinism, after one of the earliest constructivists. Leading constructivists are Antoine Pevsner, Naum Gabo, and László Moholy-Nagy; Alexander Rodchenko and Vladimir Tatlin both applied constructivist principles to architecture and DESIGN.

CONTENT The subject matter of a work of art.

CONTINUOUS REPRESENTATION The depiction of two or more successive, episodic scenes in one picture. These scenes are most often depicted in vertical or horizontal succession to represent movement in time. Such pictorial organization is seen in Egyptian, Roman, and medieval Western art.

CONTOUR The shape of the boundary of a FORM. The illusion of a line enclosing a form.

CONTRAPPOSTO An Italian term that describes an asymmetrical pose in which one part of the body twists away from the other. Such poses were popular with the Greeks and Romans, whose sculptural figures often carried most of their body weight on one leg. The resulting "S"-curved body was also highly developed in the art of Michelangelo.

CONVERSATION PIECE A group portrait, with figures usually less than life-size, linked by a theme, such as a family setting, and grouped informally as though in conversation or coming together in the normal course of everyday life. Very popular in the 18th century, especially in England.

COPPER ENGRAVING ENGRAVING on a copper plate, the most widely used method of engraving until the 19th century. Copper engravings show a softer line than engravings made from a steel plate.

COPTIC ART EARLY CHRISTIAN ART in Egypt from the 3rd to the 9th centuries. It began as a distinct style with the realistic FAYUM PORTRAITS and eventually developed into flat, decorative, ornamental art.

COPY Intentional imitation (facsimile) of an ORIGINAL work of art. As opposed to a FAKE, a copy generally is not intended to deceive. However, the prevalence of APPROPRIATION in contemporary art has blurred the lines between copies, fakes, and ORIGINALS.

CORBEL A projecting BRACKET that supports a beam. Often decorated with sculpture.

CORING The restoration of a wood panel by the removal of damaged areas and the reinforcement of the thin original with two sheets of wood glued to the back, the first with the grain running at right angles to the grain of the original, the second with

the grain running parallel to that of the original, forming a three-ply lamination.

CORNICE Any ornamental MOLDING that completes the part to which it is attached. A cornice is a common architectural member on FACADES, but applies to a molding at the junction of a wall and ceiling as well. In classical architecture, it is the crowning molding of an ENTABLATURE. (*Fig. 1*)

COSMATI WORK Architectural and decorative stone surfaces inlaid with cubes of colored glass, marble MOSAIC TESSERAE, and GILDING, produced in Italy from the 12th to the 14th centuries. From Cosmati, the family of craftsmen who worked in the technique.

COULISSE (Fr., wing, as in a theater) Compositional elements — clumps of trees, groups of figures, buildings, etc. — arranged in tiers at the sides of a picture to direct the eye into the center picture space. Common in BAROQUE painting. See REPOUSSOIR.

COUNTERPROOF A PRINT taken by impressing a sheet of paper against a damp PROOF, not against the plate. Used by an artist to study the plate, the counterproof's image is reversed from that of the normal proof and corresponds to that of the plate.

CRACKLE A network of fine cracks on the GLAZE of oriental and modern PORCELAIN, produced by intentional CRAZING. Also, the surface of an oil painting when broken by a network of small cracks (CRAQUELURE).

CRADLING Strengthening a wood panel by gluing slotted strips of hardwood vertically to the back, then passing other strips horizontally through the slots. The slotting allows for natural expansion and contraction.

CRAFT In traditional art history the line between art and craft was sharply defined. Crafts were always practical, if sometimes beautiful, objects produced by a skilled tradesman. Until the 16th century, both craftsmen and artists were paid according to the labor expended in making an item; with the rise in the status of the artist, however, artworks came to be viewed primarily aesthetically. This division is breaking down as more DESIGN and once-practical objects are adopted by the ever-expanding definition of art (e.g., Shaker craft and art, automobile design) and as artists turn to methods once exclusively those of craftspeople (e.g., quiltmaking, as seen in the AIDS memorial quilt or African-American artists working in the quilt medium; woodwork, furniture design). See "LOW" ART, "HIGH" ART.

CRAQUELURE (Fr., cracking) The network of hairline cracks in the PIGMENTS and varnishes of old paintings. Craquelure is commonly faked on intentionally deceptive reproductions.

CRAYON Stick of colored drawing material made of dry PIGMENT and chalk bound with gum tragacanth. Crayons are the drawing medium of pastel. Wax sticks of color patented under various trade names are known incorrectly as crayons.

CRAZING Cracks in the GLAZE of POTTERY resulting from improperly blended cement or the unequal shrinking of vessel and glaze as the piece cools after firing. It may be either deliberate or unintentional.

CRESTING Ornament along the top of a wall, screen, or roof.

CREWEL Embroidery using colored worsted yarn. Common in England and the U.S. during the 18th and early

19th centuries, crewel embroidery was chiefly used for drapes and upholstery.

CROCKET Stylized leaf ornament projecting at regular intervals from GABLES, spires, FINIALS, etc., chiefly in GOTHIC architecture. (*Fig. 9*)

CROSS Symbol of Christ's sacrifice and, more generally, of the Christian religion. By the 5th century it had become the adornment of choice for early Christians on SARCOPHAGI and other objects. During the Middle Ages, variations in the shape and style proliferated, including the GREEK, LATIN, Celtic, and papal crosses. Used by guilds and borne on arms and banners, they came to represent ecclesiastical authority; their shapes also formed the ground PLANS of churches. For ICONOGRAPHICAL purposes in painting and sculpture, variations on the cross and its relation to other objects serve as an ATTRIBUTE of saints and/or narrative scenes from the life of Christ.

CROSS-HATCHING See HATCHING.

CROSSING That area in a church where the TRANSEPT intersects the NAVE and CHANCEL. (*Fig. 4*)

CRYPT Room beneath the pavement of a church or cathedral. Often used as a burial chamber.

CRYSTAL PAINTING See TINSEL PAINTING.

CUBISM A major direction of modern art begun as a reaction to IMPRESSIONISM and led by Pablo Picasso and Georges Braque. About 1907, cubism took up Paul Cézanne's quest for basic geometric forms in nature by dissecting FORM (ANALYTIC CUBISM). About 1915, it sought an imaginative reorganization of those forms in various contexts (SYNTHETIC CUBISM). Since cubism was chiefly concerned with the liberation of form, color played a secondary role in

cubist art. By 1915, the major cubist achievements were complete.

CUBIST-REALISM, CUBO-REALISM See PRECISIONISM.

CUPOLA Small ornamental roof structure. See BELVEDERE.

CURTAIN WALL This non-load-bearing wall was first made possible with the introduction of the structural steel skeleton by Louis Sullivan in the Carson Pirie Scott store (Chicago, 1899–1904). Years later Walter Gropius acknowledged that in "modern architecture the wall is no more than a curtain or climate barrier, which may consist of glass if maximum daylight is desirable." As a result, in 1925–1926, he created the workshop wing for the Dessau BAUHAUS which became the precursor to the characteristic glass box building of the INTERNATIONAL STYLE. See BEARING WALL.

CURVILINEAR Characteristic of curving lines. Late GOTHIC TRACERY and ART NOUVEAU ornament are examples of curvilinear treatment of form.

CUSP A projecting point at the intersection of FOILS in GOTHIC TRACERY.

CYCLADIC ART See AEGEAN ART.

CYLIX See KYLIX.

CYMA A double curve, most common in architectural and furniture MOLDINGS. Cyma-recta is concave above and convex below; cyma-reversa is convex above and concave below.

DADA An international movement in the FINE ARTS, drama, and literature that took shape in Zurich in 1916, with other major centers in New York (1915–1920), Germany (1918–1923), and Paris (1919–1922). Symbolizing their antirational stance, founding artists "chose" the word "Dada" (Fr., hobby horse) by sticking a penknife into a dictionary at random. The movement reflected the cynicism engendered by World War I in improvised, sarcastic expressions of intuition and irrationality. Dada artists—among them Marcel Duchamp, Jean Arp, Francis Picabia, Kurt Schwitters, and Max Ernst—APPROPRIATED PAPIERS COLLÉS for their witty COLLAGES and READY-MADES for their sculpture. A forerunner of SURREALISM. See ANTI-ART.

DAGUERREOTYPE A product of the first widely used photographic process (1839 onward), named after its inventor, L. J. M. Daguerre. A daguerreotype is made without a negative by exposing a silver halide coated copper plate and then fuming it with mercury vapor to bring out the image, which characteristically appears in reverse. More popular than the contemporary CALOTYPE process, the daguerreotype was gradually supplanted after 1851 by the COLLODION WET PLATE process.

DAMASCENE Technique of decorating iron and steel with flat patterns of gold and silver. Introduced from the

Near East via Italy, damascening is most often seen in decorated arms and armor.

DEACCESSIONING In the late 1980s the art market experienced an enormous boom and prices skyrocketed for all artworks, but especially for IMPRESSIONIST and MODERN paintings. Acquisition budgets at most museums could not keep up with the new prices. In order to acquire new and important works, some museums resorted to the sale of what were considered secondary or redundant works in their collections. The auctioning off of several works then supplied the funds to buy one or two paintings which could fill gaps in the existing collection. Deaccessioning was controversial, raising questions as to whether such decisions reflected current tastes and would stand the test of time.

DEAD COLORING See UNDERPAINTING.

DECADENT MOVEMENT See FIN DE SIÈCLE.

DÉCOLLAGE The tearing away of parts of posters, etc., that have been applied in layers, so that selected portions of the underlayers contribute to the total image. The reverse of COLLAGE. Associated with NEW REALISM.

DECONSTRUCTION In architecture deconstruction is a more disruptive element within a POSTMODERN ZEITGEIST. Architectural postmodernism often enacts a nostalgic reinvestment of meaning through the inclusion of historicizing references such as CLASSICAL COLUMNS and ornamentation. Deconstructive architecture, on the other hand, seeks a deregulation of architectural meaning and function. Bernard Tschumi's structures at the Parc de la Villette in Paris do away with the great synthesis of modern architecture: form follows function. Their playful

uselessness is a travesty of the functionalist paradigm. See SEMIOTICS.

DECORATED STYLE The second phase of English GOTHIC architecture, following the EARLY ENGLISH and preceding the PERPENDICULAR STYLE. Flourished in the 14th century and is recognized by geometric or flowing TRACERY designs.

DECORATIVE ARTS Imprecise collective term for such art forms as CERAMICS, ENAMELS, furniture, glass, ivory, metalwork, and textiles, especially when they take forms used as interior decoration. Sometimes designated the "MINOR" ARTS to distinguish them from the "major arts" of architecture, sculpture, and painting. See APPLIED ARTS, CRAFT, "LOW" ART.

DEGENERATE ART See FASCIST AESTHETIC.

DEL., DELIN. (Lat., delineavit = has drawn it) On a print, signifies that the artist whose name it follows was responsible for the original design, as distinct from being the engraver, etc. Used like *pinxit* (see P., PINX., PINXIT, PICTOR) and *invenit* (see IN., INV., INVENIT, INVENTOR).

DESIGN The COMPOSITION or general conception of a total work of art, or a part of it. Since the 19th century, applied also to the creation of pleasing and well-formed useful objects.

DE STIJL Now synonymous with the term NEO-PLASTICISM, *De Stijl* was the name of a Dutch journal started by Theo van Doesburg in 1917 which, as the organ of neo-plasticism, was influential in spreading the theories of Piet Mondrian. These ideas strongly marked the architectural, industrial, and commercial design at the BAUHAUS.

DIMINISHING GLASS See REDUCING GLASS.

DINANDERIE General name for brass utensils, named after the Belgian town of Dinant, an important medieval center for brass ware.

DIORAMA A device invented by L. J. M. Daguerre and Charles Bouton in 1822 for producing changing effects in a painting. A partly translucent painting is viewed from a distance through an opening in a chamber. By manipulating the direction, color, and intensity of lights, a diversity of scenic effects may be produced.

DIPTYCH A picture, usually an ALTARPIECE, made of two panels hinged together.

DIRECT PAINTING See ALLA PRIMA.

DIRECTOIRE Style of French decorative arts seen between 1793 and 1804 and viewed as transitional between the NEOCLASSICAL style of Louis XVI and the French EMPIRE STYLE. Directoire style combines neoclassical motifs with Napoleonic revolutionary emblems and, in its last years, with ornament derived from ancient Egyptian art. See REGENCY STYLE.

DISEGNO (It., design or drawing) In Italian Renaissance art, refers to the total concept or DESIGN of a work of art.

DISTEMPER Paint prepared from water, powder colors, and SIZE. Used for large-scale decorative or MURAL painting when permanence is not important. Not to be confused with true FRESCO.

DIVISIONISM See NEO-IMPRESSIONISM.

DOLMEN Unmortared, upright stones or boulders that support a horizontal stone slab. Those at Stonehenge in England are thought to have served in prehistoric

religious observances, while others at Carnac, France, were "houses of the dead."

DOME A hemispherical, or nearly hemispherical, roof formed of evenly curved VAULTS which may rise from either a circular or a polygonal base. A circular dome is accommodated to a noncircular base by means of PENDENTIVES. (*Fig. 5*)

DOTTED PRINT ENGRAVING made by punching the design into the metal plate. The process, also called manière criblée, was practiced mainly in the late 15th and early 16th centuries.

DRAGGING A method of applying PIGMENT mixed with little or no VEHICLE by dragging it lightly over the tacky surface of a painting, to produce an effect of broken color.

DRIER See SICCATIVE.

DRÔLERIES Humorous and often fantastic pen drawings in the margins of medieval MANUSCRIPTS.

DRUM A cylindrical or polygonal base sometimes introduced to raise a DOME or CUPOLA to a greater height than it would otherwise attain. The drum rests on PENDENTIVES and is of the same diameter as the dome. (*Fig. 5*)

DRY BRUSH A technique of drawing, WATERCOLOR, and also oil painting in which little color is put onto a brush and then skimmed over a surface. Color is left only on the raised points of that surface, which gives a soft, sketchy tone and effect.

DRY PLATE See GELATIN DRY PLATE.

DRYPOINT A process of ENGRAVING in which the BURR raised by the sharp steel BURIN is allowed to remain—not

polished away as in LINE ENGRAVING—producing a soft, velvety effect. The softness diminishes with each print. Invented ca. 1480.

DUECENTO OR **DUGENTO** (It., two hundred) The 13th century, used especially when referring to Italian art and literature of that century.

DWARF GALLERY Exterior wall passage with a small or low ARCADE, most often located just below the roof. Common feature of German and Lombardic ROMANESQUE architecture.

EARLY CHRISTIAN ART Term referring to the early centuries of Christian art (3rd to 6th) when Christian subject matter was rendered in the prevailing styles of late Roman art.

EARLY ENGLISH STYLE The first period of English GOTHIC architecture, ca. 1190–1280. The LANCET WINDOW without MULLIONS was a characteristic feature, hence the occasional designation "lancet" for the style.

EARTH ART An umbrella term for related movements originating in the mid-1960s in which substances like dirt, rocks, snow, and grass are embraced as the artist's MEDIA. Works range in size from gallery pieces to large tracts of land, such as Robert Smithson's *Spiral Jetty* (1970), which jutted 1,500 feet into the Great Salt Lake. As with many site-specific works, these may be known to the public primarily through photographic documentation. Amalgams from the 1980s have resulted in new trends termed eco-feminism, eco-Dada, and environmental protest art. Compare ENVIRONMENT ART.

EARTH COLORS Those PIGMENTS, such as yellow ochre, terra verte, umber, and Venetian red, whose hues derive from metal oxides.

EARTHENWARE CERAMIC WARE of porous white body to which a shiny GLAZE is fused at a low temperature.

```
    #100   08-01-2007 6:45PM
Item(s) checked out to Leon, Alejandro M

TITLE: The Bulfinch pocket dictionary of
BARCODE: 33220002375173
DUE DATE: 08-18-07

TITLE: The Adeline art dictionary : incl
BARCODE: 33220000179247
DUE DATE: 08-18-07
```

EARTHWORKS See EARTH ART.

EASEL PICTURE Small- or moderate-size painting executed at an easel. Renaissance artists began painting easel pictures to meet the demand of collectors, and they were often displayed on easels. They became immensely popular when the middle class in 17th-century France and Holland began to collect art. Also called cabinet picture.

EASTLAKE STYLE A style of decorative ornamentation of architecture and furniture named for the English painter and critic Charles Locke Eastlake. Heavy use of machine-turned and lathed brackets, balusters and other architectural ornaments, and also furniture surfaces carved with angular designs characterize Eastlake style, which flourished between 1870 and 1885.

ÉBÉNISTE (EBONIST) Specifically refers to a furniture maker or cabinetmaker belonging to the French Corporation de Menuisiers-Ébénistes during the second half of the 18th and early part of the 19th centuries. By extension, denotes any maker of luxury furniture of the ornate, French veneer inlay variety.

ECCE HOMO (Lat., behold the man) Representation of Christ when presented to the people for crucifixion.

ECHINUS The subtly curved convex MOLDING beneath the ABACUS of a Doric CAPITAL. *(Fig. 1)*

ECLECTICISM A theory taught in the late 16th century by the Carracci at their academy in Bologna, based on the idea that the painter should choose the best of various schools and masters and combine these qualities in his own work. In a general sense, borrowing from a variety of visual sources in the creation of a work of art or architecture.

ÉCORCHÉ (Fr., flayed, without skin) A figure, usually in the form of a statuette, shown without skin to expose the muscular construction of the body

EDITION All the copies of a book made from one typesetting. In GRAPHIC ARTS, it is synonymous with STATE.

EGG-AND-DART Classical decorative motif consisting of an alternation of oval forms with pointed, dart-like shapes.

EGYPTIAN REVIVAL STYLE In American architecture, this style occurred twice: ca. 1830–1850 and 1920–1930. Used mostly for public monuments and commercial buildings, the forms are heavy, often PYLON-like. Reeded COLUMNS, palm CAPITALS, and other ornaments are distinctively Egyptian.

EIGHT, THE Arthur Davies, William Glackens, Robert Henri, Ernest Lawson, George Luks, Maurice Prendergast, Everett Shinn, and John Sloan. They were members of the ASHCAN SCHOOL.

ELEVATION One face or side of a structure, or a scale drawing of one side. Compare PLAN, SECTION, and ISOMETRIC PROJECTION.

EMBOSSING Carving, molding, or stamping a surface to raise a design into RELIEF.

EMPAQUETAGE A special form of NEW REALISM associated chiefly with the Bulgarian artist Christo, which consists of packaging objects with common wrapping materials, especially plastic sheeting. The best known empaquetages (wrappings) have been done on buildings, although smaller objects (such as a live woman) and larger forms (such as cliffs) have been packaged.

EMPIRE STYLE Style of DECORATIVE ARTS of the French First Empire (1804–1814) which spread to the rest of Europe and eventually to America, where it lasted until about 1840. In England it corresponds to the REGENCY STYLE. Although it takes slightly different forms in each country, empire style is dominated everywhere by NEOCLASSICISM. See DIRECTOIRE.

EMULSION A VEHICLE composed of water and oil, which will combine only with the addition of an emulsifying agent such as casein, egg, etc.

ENAMEL Colorless, white, or colored glass fused by heat to a metal or PORCELAIN base. Also, an object produced by the technique. Known to the Egyptians, it was perfected by the Byzantines (see CLOISONNÉ ENAMEL) and Germanic tribes (see CHAMPLEVÉ ENAMEL). In the 15th and 16th centuries, the painting of scenes and designs on enamel was practiced and perfected in Lorraine and Limoges.

ENCAUSTIC A technique of wall painting practiced by the Egyptians, Greeks, and Romans. Pigments in a wax VEHICLE were applied to the wall and then "burned" with heated irons or similar instruments.

ENGRAVING The art of incising lines on wood, metal, glass, etc. Also, a print or impression made by the engraving process, either RELIEF or INTAGLIO. There are many varieties of engraving, including LINE ENGRAVING, COPPER ENGRAVING, WOOD ENGRAVING, DOTTED PRINT, DRYPOINT, NIELLO, STIPPLE ENGRAVING, and MEZZOTINT.

ENTABLATURE The upper section of a CLASSICAL ORDER. Consists of three horizontal divisions, which are, from the top, CORNICE, FRIEZE, and ARCHITRAVE. (*Fig. 1*)

ENTASIS Slight swelling in the shaft of a COLUMN, devised by the ancient Greeks to overcome the illusion of concavity when parallel-sided or regularly tapered columns were used in proximity.

ENVIRONMENT ART Not to be confused with EARTH ART, in its broadest sense environment art refers to the work of artists who manipulate the man-made environment. Controlled spaces—whether sculpted or constructed of building materials or light beams or sound—are intended to be experienced with all the senses. A major theme has been the fusion of architecture and sculpture in a room space that surrounds the entering viewer, such as the life-size, three-dimensional tableaux created by Edward Kienholz. Environment art has appeared sporadically in several 20th-century movements, including DADA, SURREALISM, and POP ART.

ESQUISSE See SKETCH.

ETCHING An INTAGLIO process in which an etching needle is used to draw the design into a wax GROUND applied over a metal plate. The plate is then subjected to a series of acid bitings, is inked, wiped, and then printed. Also, a print made by this process.

ETRUSCAN ART The tomb painting, sculpture, POTTERY, and bronze ware produced by the people of Etruria in northern Italy (who were originally from Asia Minor) from the 7th to the 3rd centuries B.C. Strongly influenced by Greek art, Etruscan culture was eventually absorbed by the Romans.

EVANGELIARY Liturgical book containing the texts of the Gospels read at mass.

EX VOTO (Lat., out of thankfulness) A painted or sculptured image given to God or gods in thanksgiving for

favors and blessings. Occasionally the donor is
depicted in the work.

EXC., EXCUD. (Lat., excusit = has published it) On a print,
usually refers to the printer when it follows a
name, as distinguished from the engraver.

EXPRESSIONISM Art in which the emotions of an artist are
paramount and take precedence over a rational
and faithful-to-life rendering of subject matter.
Expressionist compositions and forms therefore
tend toward distortion and exaggeration, as in the
art of El Greco. In MODERN ART, expressionism is
associated with German movements of the early
20th century, especially DIE BRÜCKE and DER BLAUE
REITER, which are usually referred to as German
expressionism. In the Americas expressionism was
embraced by Mexican MURALISTS searching for a
national style that incorporated European and PRE-
COLUMBIAN elements. See NEO-EXPRESSIONISM.

EXTRADOS Outer curve of an ARCH. (*Fig. 6*)

EYE LEVEL (EYE LINE) In perspective, the HORIZON LINE on which
two receding parallel lines meet at a VANISHING
POINT. (*Fig. 12*)

F

F., FE., FEC., FECIT (Lat., fecit, fecerunt = has made it) On a print, signifies that the artist whose name it follows was the etcher or engraver. Used like *incidit* (see INC., INCID., INCIDIT, INCISOR) and *sculpsit* (see SC., SCULP., SCULPT., SCULPSIT, SCULPEBAT).

FACADE The front or main face of a building.

FACSIMILE See COPY.

FAIENCE (Fr., fayence, after Faenza, Italy) EARTHENWARE with an opaque, tin-based GLAZE. Also, glazed earthenware used for architectural purposes. Often incorrectly used to mean POTTERY and PORCELAIN of all kinds.

FAKE A deliberate forgery of a work of art. See COPY, ORIGINAL.

FASCIST AESTHETIC Associated primarily with Hitler, Mussolini, and Franco, this was art with propagandistic intentions clearly outlined in REALIST styles, giving it a close resemblance to SOCIALIST REALISM. In Germany, images of youthful blonds reflected myths of Aryan superiority, while the heavy, grandiose architecture at Munich and Nuremberg proclaimed an imperial destiny inherited from antiquity. It strongly contrasts with MODERN ART, dubbed degenerate (*entartete*) by Hitler. See FUTURISM, SOCIALIST REALISM.

FAT OVER LEAN A traditional principle of painting where there is OVERPAINTING of any sort: superimposed PIGMENTS should be richer in oil (fat) than the underlayer.

FAUVES, LES (Fr., the wild beasts) Originally a contemptuous appellation for a group of French POST-IMPRESSION-IST painters who exhibited their work at the Salon d'Automne in 1905. They were so called because of their use of strident color, violent distortions, and broad, bold brushwork. Their leader was Henri Matisse; others were Georges Rouault, Maurice Vlaminck, André Derain, and Raoul Dufy.

FAYUM PORTRAIT Realistic portrait of a deceased person painted on a mummy case or on the linen shroud itself, in Fayum, a province of Egypt. One of the outstanding accomplishments of early COPTIC ART.

FEDERAL STYLE An American architectural style of about 1780 to 1820 which reflected English GEORGIAN models, especially the influence of Robert Adam. Symmetrically designed FACADES, smooth surfaces, and restrained classical ornament typify buildings in that style.

FEMINISM The progressive social movements of the 1960s produced their own academic and theoretical equivalents of revision and reinterpretation. The recognition of women's historical oppression in a patriarchal society produced numerous reactions in the art world. In the early 1970s exhibitions that recovered "forgotten" women artists began to establish a CANON of great women artists. Judy Chicago produced *The Dinner Party* from CRAFT techniques traditionally associated with women, such as needlepoint and CERAMICS. By using blatant female imagery, she and others sought to make explicitly "female" works. By the late 1970s

second-generation feminism coupled with a measure of psychoanalytic theory shifted the emphasis away from biological determinism to notions of self-identity. This approach was seen as more empowering, enabling both men and women to reexamine questions of gender and sexuality in contemporary art as well as in old masterworks previously rejected for their sexism. Contemporary artists working with this approach include Barbara Kruger and Cindy Sherman.

FENESTRATION The arrangement and placement of a building's windows.

FERROCONCRETE See REINFORCED CONCRETE.

FERROTYPE See TINTYPE.

FÊTE CHAMPÊTRE (Fr., rural festival) A scene showing a country festival, e.g., Pieter Bruegel the Elder's *Dance of the Peasants*.

FÊTE GALANTE A scene of an elegant, festive occasion in an open-air setting, depicting dancing, musicales, comedy, etc. Antoine Watteau introduced the fête galante and it became a specialty of French ROCOCO art.

FIBULA A brooch used to fasten a tunic at the shoulder. A specialty of GERMANIC ART.

FIELD ART See EARTH ART.

FIGURATIVE Artwork which represents recognizable images ranging from portraits to landscapes. Compare ABSTRACT ART.

FIN DE SIÈCLE (Fr., end of century) Art of the end of the nineteenth century, also known as decadent art, which was created under the influence of the AESTHETIC

MOVEMENT in the style of ART NOUVEAU. Particularly associated with the highly stylized, black-and-white illustrations of Aubrey Beardsley.

FINE ART Describes solely those categories of artworks traditionally judged to be most prominent in terms of AESTHETIC significance. They include architecture, painting, sculpture, and many of the graphic arts and are contrasted with DECORATIVE and APPLIED ART, in which function is as important as aesthetic considerations. Within painting, HISTORY PAINTING was considered the most important, followed by portraiture and landscape.

FINIAL An ornament crowning a GABLE, ARCH, PINNACLE, etc.; common in GOTHIC architecture, usually in the form of a stylized fleur-de-lis. (*Fig. 9*)

FIXATIVE A thin, colorless solution sprayed on drawings in pencil, chalk, PASTEL, charcoal, or other impermanent material to prevent smudging.

FL. Abbreviation for "flourished," referring to the years of creative output in an artist's life.

FLAKING See SCALING.

FLAMBOYANT STYLE The last phase of French GOTHIC architecture, after about 1460, characterized by elaborate flowing window TRACERY.

FLUTING Decoration consisting of carved shallow vertical grooves on COLUMNS, PILASTERS, etc.

FLUXUS An international art movement, founded in Germany in 1962, which spread quickly throughout Europe and, later, to the United States. It was largely CONCEPTUAL in nature, and the group maintained no stylistic identity, preferring instead many activities that revived the spirit of DADA. George

Maciunas, Fluxus's founder and leader, championed anti-institutional street skits, guerrilla theater, and PERFORMANCES.

FLYING BUTTRESS A bridge of masonry that transmits the thrust of a VAULT or roof to an outer support. Characteristic of GOTHIC architecture. (*Fig. 9*)

FOIL An arc-shaped form which is used in combination with CUSPS, especially in GOTHIC TRACERY, to form lobed decorations. See TREFOIL, QUATREFOIL.

FOLIO A book or MANUSCRIPT having pages of the largest common size, which is more than 30 cm (12 inches) in height. Also, a sheet of paper folded once to form two leaves.

FOLK ART The arts of peasant societies, both past and present. Characterized by naive subject matter and a vivacious style, folk art both perpetuates very ancient decorative traditions and draws selectively from art forms of sophisticated cultural traditions, e.g., the adaptation of 18th-century ROCOCO motifs in European folk art. Paintings, sculpture, CERAMICS, metalwork, costume, needlework, implements, and tools all may be folk art. See NAIVE and "OUTSIDER" ART.

"FOLLOWER OF" In attributing a work of art, usually refers to an anonymous imitator of the artist named. Compare "CIRCLE OF," "MANNER OF," SCHOOL, WORKSHOP.

FOLLY A whimsical architectural structure with little use other than enhancing a landscape view in a park and/or serving as a conversation piece. Popular in 18th-century England.

FORE-EDGE PAINTING A painting on the edge of a book opposite the spine, occasionally on the top edge, vis-

ible when the book is fanned slightly. Landscape is the most common subject.

FORESHORTENING The application of PERSPECTIVE to forms in order to create the illusion of three-dimensionality and depth.

FORM In art, the presentation of various shapes, either recognizable or abstract; the visible result of an artist's conception of the subject, but not the subject matter itself. See CONTENT.

FORMALISM A central tenet of modernist art criticism that emphasized the importance of line, color, and space (SIGNIFICANT FORM). Representational CONTENT was considered irrelevant in the eyes of formalist critics. Since formalism provided "objective" methods for looking at all art whether Western or not, ancient or contemporary, it was thought of as egalitarian. But the advent of POP ART necessitated a different analysis that went beyond the work itself and examined influences from POPULAR CULTURE. POSTMODERN approaches to art-making and criticism investigate both FORM and content, as well as the context of art and its role in society.

FORUM The Roman equivalent of the Greek AGORA. The central square or open marketplace surrounded by public buildings.

FOUND OBJECT (Fr., objet trouvé) Any found (not looked for) natural or man-made object which is regarded by an artist as aesthetically significant. Shown as, or incorporated into, works of art by the DADAISTS and SURREALISTS. Compare READY-MADES.

FOURTH DIMENSION A non-Euclidean geometrical concept that first became popular in France around 1910 and that may have influenced the CUBISTS. Picasso and Braque as well as Marcel Duchamp painted

objects from multiple perspectives, suggesting a synthesis of views taken at various points in time. Contemporary artists such as Tony Robbin are once again dealing with issues of the fourth dimension by using computers and concepts based in physics and mathematics. See RAYONISM.

FOXING A discoloration of paper in books, on prints, etc., due to dampness. Seen as brown spots.

FRAKTUR Gothic or black-face type. Also, Pennsylvania German CALLIGRAPHY, especially ILLUMINATED birth, baptismal, and marriage certificates executed in script derived from German fraktur script.

FRESCO Called "buon fresco" or "true fresco," the technique of painting on moist lime plaster with water-based PIGMENTS.

FRESCO SECCO A process similar to buon fresco (see FRESCO), except that the plaster is allowed to dry before PIGMENT is applied. Less permanent than buon fresco.

FRET A type of ornamental pattern, seen in many variations, consisting of straight lines joining at right angles, sometimes intersecting other such lines at right angles.

FRIEZE The middle section of the ENTABLATURE between the ARCHITRAVE and the CORNICE, where RELIEF sculpture was sometimes applied. Also, in interiors, the broad band between wall paneling and ceiling. (*Fig. 1*)

FROTTAGE (Fr., rubbing) Technique of capturing designs and textural effects by placing paper over objects that have raised surfaces and rubbing the paper with graphite, wax crayon, etc. Also called rubbing, it is a popular way of copying forms in nature,

gravemarkers, manhole covers, etc. Frottage was a favored technique of SURREALIST artists.

FUGITIVE PIGMENT PIGMENT that either fades with prolonged exposure to light, is susceptible to atmospheric pollution, or tends to darken when mixed with other substances.

FUNK ART A term coined in the 1960s to describe a class of art that emerged in the San Francisco Bay area. It was often witty, sometimes deliberately distasteful, with a diversity of styles ranging from comic-strip derivations to William Wiley's use of FOUND OBJECTS. Funk artists looked to POPULAR CULTURE rather than traditional CANONS of FINE ART.

FUTURISM Chiefly an Italian literary and artistic movement, futurism stressed the dynamism of motion and appealed to young Italian artists to reject the art of the academies and museums. The first "Manifesto of Futurist Painters," proclaimed in 1910 in Turin, was signed by Umberto Boccioni, Carlo Carrà, Giacomo Balla, Gino Severini, and L. Russolo. Attempting to represent time and motion, these painters and sculptors showed multiples of moving parts in many positions simultaneously. While futurism was not directly associated with fascism until after World War I, evidence of right-wing political ideas and the glorification of war can be found in Boccioni's *States of Mind* of 1910–1911.

GABLE Triangular area of a wall which meets a ridged or peaked roofline.

GADROON In architecture, a convex MOLDING which is elaborately carved or indented. In silversmithery or furniture, a border formed of a series of inverted FLUTING forms.

GALLERY In church architecture, an upper story over the SIDE AISLE which is open toward the NAVE. Feature of ROMANESQUE and early GOTHIC architecture.

GALVANOPLASTIC COPY A FAKE or COPY of a silver or bronze medal, statue, plaquette, RELIEF, etc., made by electrolysis.

GARGOYLE A waterspout in the form of an open-mouthed GROTESQUE, projecting from an upper gutter of a building to carry water clear of the walls. Common in GOTHIC architecture.

GELATIN DRY PLATE A photographic process using a glass plate negative coated with silver halide suspended in gelatin. In wide use after 1873, gelatin dry plate replaced COLLODION WET PLATE and had the advantages of a shorter exposure time and greater convenience for the photographer.

GELATIN PRINT A name for black-and-white photographic prints made on paper coated with gelatin contain-

ing light-sensitive silver halide. It is the standard print process now in use. Also called silver print and gelatin-silver print.

GENRE In a broad sense, the term may refer to a type of art, such as landscape or portraiture, within the general category of painting; in a specialized sense, it refers to the portrayal of scenes from unidealized daily life: domestic and tavern scenes, musicales, FÊTES CHAMPÊTRES, etc. The term applies especially to painting. Genre scenes can be the entire subject or just a detail in a nongenre picture. Explored as a distinct type of BAROQUE painting in the Low Countries.

GEOMETRIC ART A term associated with a style of early Greek art (ca. 1000–700 B.C.) in which decoration is formed of angular lines and shapes. Vase painting is the chief expression of Greek geometric style art. Also used to describe the style of art produced by a variety of prehistoric and primitive cultures.

GEORGIAN STYLE Style of architecture, furniture, and interior decoration developed in the reigns of the four English King Georges (1714–1830). In England, the three phases are: PALLADIAN, NEOCLASSICAL, and REGENCY. In the United States: Georgian, FEDERAL, and ROMAN CLASSICISM. All forms show classical inspiration and Renaissance spirit and motifs.

GERMAN EXPRESSIONISM See EXPRESSIONISM.

GERMANIC ART Art of the migrating Germanic tribes from the 4th to the 9th centuries. Characterized by the near absence of the human figure and preference for animal forms (ZOOMORPHIC ORNAMENT) and LACERTINE. Metalwork and jewelry were specialties. Also called barbaric art. See VISIGOTHIC ART.

GESAMTKUNSTWERK (Ger., total work of art) Term applied to that art of the BAROQUE and ROCOCO periods which sought unification of architecture, sculpture, painting, and sometimes even the APPLIED and DECORATIVE ARTS into a "total work of art." For example, Gianlorenzo Bernini's execution of the Coronaro Chapel in S. Maria della Vittoria in Rome. By extension, the same idea applies to other periods.

GESSO Plaster of Paris or gypsum. A GROUND for TEMPERA painting and early types of oil painting prepared from a mixture of gypsum, SIZE (glue), and water.

GILDING The process of covering surfaces with gold leaf. Applied to a tacky base of gold SIZE (glue) or thick oil varnish, then burnished.

GISANT (Fr., recumbent) A sculptured, recumbent effigy which lies on the lid of the deceased's tomb.

GLASGOW SCHOOL A group of painters gathered in Glasgow, ca. 1850–1918, who rejected academic conventionality and painted in a spirited style of NATURALISM. The best known of them include David Young Cameron and E. A. Walton.

GLAZE A translucent film of color applied over a thoroughly dry underlayer of oil or TEMPERA. Generally a glaze is most successfully applied over a light hue. In CERAMICS, glaze is the glossy, vitreous surface produced by coating a vessel with a substance similar in composition to clay but with a fluxing agent added to permit melting at a temperature lower than that of the clay. The main classes of ceramic glaze are lead, tin, and salt.

GLORY A general term for the representation of an emanation of light around a sacred personage. AUREOLE, halo, NIMBUS, and MANDORLA are types of glories.

GLYPTIC Carved, not molded or modeled. Compare PLASTIC.

GOLDEN PAINTING See TRANSLUCID PAINTING.

GOLDEN SECTION (golden mean) A geometrical proportion known at least since Euclid and regarded as a universal law of the harmony of proportions in both art and nature. The common formula is: to divide a finite line so that the shorter part is to the longer part as the longer part is to the whole.

GOTHIC ART Last phase of medieval art, beginning ca. 1140 in Paris and spreading in the 13th century throughout Western Europe; succeeded by the RENAISSANCE in the 14th century in Italy and in the 16th century in the rest of Europe. Early gothic, to 1200; high gothic, to ca. 1250; late gothic, after 1250. The greatest contribution of gothic art was the cathedral, with its elaborate architecture, complicated architectural decoration, and large-scale STAINED-GLASS panels.

GOTHIC REVIVAL A picturesque style of architecture and decoration of the 19th century which incorporated adaptations of medieval GOTHIC elements. In architecture, asymmetrical design, verticality, steeply pitched, gabled roofs, and much ornate TRACERY-derived ornament are seen.

GOUACHE A painting MEDIUM made of opaque PIGMENTS in a water base. Also, a painting in that medium.

GRAFFITI ART (It., scratched) Beginning in the 1970s with the availability of aerosol spray paints, illegal graffiti statements and designs began to coat New York subway cars. Whereas political art took art from inside galleries into the streets, the graffiti art movement APPROPRIATED this element of street culture and brought it into the elite world of New York art galleries. There, untrained artists like

Jean-Michel Basquiat enjoyed brief recognition, while Keith Haring's self-conscious use of the style made him its most famous proponent. Once in the galleries, however, graffiti art lost its element of illegal performance, its power as protest, and its context. Neutralized, it became fashion and quickly went out of style.

GRAFFITO See SGRAFFITO.

GRAND STYLE (grand manner) The representation of the human figure in elevated themes or noble settings. Term used to describe the artistic ideal of the HIGH RENAISSANCE that was promoted in ACADEMIES.

GRAPHIC ARTS The class of visual arts in which lines, marks, or characters are impressed on a flat surface, usually paper. These include drawing, ENGRAVING, ETCHING, LITHOGRAPHY (which are grouped with FINE ART) and also processes such as typography and printing, when they are intended for more than utilitarian purposes.

GRAVER See BURIN.

GRAVURE An INTAGLIO commercial printing process using ETCHED or ENGRAVED plates or cylinders.

GREEK CROSS CROSS with arms of equal length. Often used as the basis for churches having a centralized PLAN, especially in BYZANTINE architecture.

GREEK REVIVAL A form of NEOCLASSICISM especially identified with American architecture of about 1820–1860 for which the Greek temple was the primary design source.

GRISAILLE (Fr., grayed tones) MONOCHROME painting in shades of gray; often an illusionistic representa-

tion of RELIEF sculpture, especially in connection with GOTHIC ALTARPIECES.

GROIN Curved edge formed by the intersection of two VAULTS. (*Fig. 8*)

GROIN VAULT VAULT made by the intersection at right angles of two identically shaped BARREL VAULTS.

GROTESQUE A work of DECORATIVE ART composed of fancifully painted or sculpted human and/or animal forms amid tendril-like foliage and scrolls.

GROUND In painting, a coating suitable for receiving PIGMENT. It is applied to a canvas or other SUPPORT. In ETCHING, the gummy material spread over the metal plate before drawing with the etching needle. Also, the clay of a CERAMIC vessel that serves as a field for painted decoration.

GUILLOCHE An ornament, Greek in origin, formed of a repeating PATTERN of interlacing bands in a circular or spiral design. The center of each spiral may contain a disc, or eye.

HACHURE See HATCHING.

HALFTONE In photoengraving, a process in which gradations of light (value) are obtained by manipulating the density of minute dots on the printing surface. The conversion of image to dots is achieved by photographing the subject through a special screen. Halftones have been in commercial use since 1878.

HALL CHURCH Church with NAVE and SIDE AISLES of equal height. In German, Hallenkirche.

HAPPENING Happenings developed from a combination of ASSEMBLAGE and ENVIRONMENT ART as artists sought to free art further from the constraints of the wall and the frame. Resembling PERFORMANCE, these events often involved sculpture, sound, time, motion, and living persons. While participants began with a plan, there was no rehearsal and no repeat performance. Spontaneous audience participation was sometimes encouraged. Allen Kaprow is credited with inventing happenings, most of which took place in New York City in the 1960s.

HARD-EDGE PAINTING A term used by critic Jules Langsner in 1959 in speaking of paintings executed in broad, flat areas of color delineated by precise, sharp edges. It developed as a reaction to the spontaneous and painterly handling typical of ABSTRACT

EXPRESSIONISM. Explored by Ellsworth Kelly, Ad Reinhardt, and Alexander Liberman, among others.

HARD PASTE "True," vitreous PORCELAIN, compounded of kaolin and petuntse, GLAZED with petuntse and a flux. Developed by the Chinese and imitated in Europe with SOFT PASTE PORCELAIN.

HARLEM RENAISSANCE With the largest concentration of African-American, West Indian, and African populations in the U.S., Harlem had become the "Negro Capital" (as it was then called) of America by the early 20th century. After World War I, the flourishing intellectual, artistic, musical, and political scene focused on historical recollection and redefinition of the African-American experience. Among the best-known artists are Aaron Douglas, William Johnson, and Jacob Lawrence.

HATCHING The creation of tonal effects by applying closely spaced parallel lines. When another group of lines crosses the first at an angle, it is called cross-hatching. Also called hachure.

HELLENISTIC ART Term describing the later and less CLASSICAL phase of Greek art, ca. 300 to 100 B.C. Also applied to Greco-Roman art and architecture.

HERM PILLAR-form sculpture of CLASSICAL antiquity, typically with a bearded face, armless torso, and prominent phallus. Originally, it probably represented the god Hermes. In European ICONOGRAPHY it is symbolic of revelry and abandonment.

HIERATIC An expression used to designate the severe, stylized forms of BYZANTINE ART (and its derivatives) in which the presentation of the sacredness of a per-

son or thing takes precedence over any naturalistic qualities.

"HIGH" ART An alternative and current term for FINE ART. When employed in the more general sense, it refers to art that is of universal transcendence, having withstood the test of time and representing the epitome of artistic achievement.

HIGH RENAISSANCE ART Climax of RENAISSANCE ART, ca. 1495 to 1520. In the work of Leonardo da Vinci, Raphael, and Michelangelo, Italian art attained the High Renaissance ideal of harmony and balance within the framework of classical REALISM.

HISPANO-MOORESQUE General term encompassing all artwork, architecture, and DECORATIVE ART produced in Spain under Muslim and Christian reigns and the resulting hybrid styles. Dates from the 8th to the 16th centuries. See MOZÁRABE and MUDÉJAR styles.

HISTORY PAINTING Painting with themes from or allusions to important historical events, classical literature, and the Bible. From the Renaissance to the 19th century, it was regarded in ACADEMIES as the highest, most worthwhile kind of painting. Only toward the end of the 18th century did themes from contemporary history become acceptable. Compare NARRATIVE ART.

HOLOGRAPH A three-dimensional image created by a beam of laser light passing through a hologram wave interference photograph.

HORIZON LINE A line across a picture, roughly parallel to the top and bottom edges, at which sky and earth appear to meet. The VANISHING POINT or points are located on this line. (*Fig. 12*)

HUDSON RIVER SCHOOL Group of American REALIST land-
scape painters active between about 1820 to
1880 whose favorite subjects were scenes of the
Hudson River Valley and the Catskill Mountains.
Famous members were Thomas Cole, Asher
Durand, and Frederic Church.

HUE See COLOR.

HUMANISM The belief, Renaissance in origin but inspired by
classical civilization, that man is potentially the
master of all things, and that by study and scien-
tific inquiry such mastery is within his grasp. In
art, humanism caused a gradual secularization of
themes.

HYPOSTYLE HALL A large hall with a flat roof resting on
PILLARS. Associated almost exclusively with
Egyptian architecture.

ICHNOGRAPH A ground PLAN; a horizontal SECTION showing true dimensions according to a geometric scale.

ICON (Gr., ikon = image, portrait) Very generally, a portrait. More specifically, in BYZANTINE, Greek, and Russian Orthodox church art, a type of representation of Christ, the Virgin, or a saint in painting, MOSAIC, or BAS-RELIEF (but never sculpture) in a rigid and HIERATIC stereotype developed between the 9th and 15th centuries.

ICONOGRAPHY The area of study dealing with the description of visual images and symbols. Art historian Erwin Panofsky first made the distinction between the identification of images (iconography) and the interpretation of their meaning (ICONOLOGY). See ALLEGORY and REPRESENTATION.

ICONOLOGY The science of interpreting the meaning of visual images and symbols. See ICONOGRAPHY, SEMIOTICS.

IKONOSTASIS In a Greek or Russian Orthodox church, the ICON-covered screen that separates the SANCTUARY from the public areas.

ILLUMINATED MANUSCRIPT See MANUSCRIPT.

ILLUMINATION Ornamental initial, PATTERN, or illustration painted on the vellum or parchment leaves of a MANUSCRIPT as an adornment of the text. The paint

is water soluble, with an egg base. See MINIATURE PAINTING.

ILLUSIONISM The use of optical principles to create the illusion that a painted object is real. Among the techniques are PERSPECTIVE, FORESHORTENING, and CHIAROSCURO. QUADRATURA and TROMPE L'OEIL are other forms of illusionism.

IMARI Type of Japanese export PORCELAIN made at Arita. Imari ware combines red and gold over blue underglaze decoration.

IMMACULATE PAINTING See PRECISIONISM.

IMP. (Lat., impressit = has printed it) Synonymous with EXC. when it appears on a print.

IMPASTO A particularly thick or heavy application of paint, showing the marks of brush, palette knife, or other tool of application. Also called loaded brush, pastose.

IMPRESSION Any print made from a block, plate, or stone. Also, the physical contact of paper and printing surface which in turn affects the quality of the image. Thus terms like "good impression" and "weak impression" describe that effect of the contact.

IMPRESSIONISM The 19th-century French movement, well developed by the time of the first impressionist exhibition in 1874, that is now regarded as the culmination of REALISM. The impressionist painters analyzed natural effects with devoted intensity. They devised the SPECTRUM PALETTE and relied on OPTICAL MIXING to capture the impression of light at a given moment. The most important of them include Edgar Degas, Edouard Manet, Claude

Monet, Camille Pissarro, Pierre-Auguste Renoir, and Alfred Sisley.

IMPRIMATURA A colored GROUND or thin, colored undertint applied over an outline or preliminary drawing.

IN., INV., INVENIT, INVENTOR (Lat., invenit = has invented it) On a print, refers to the artist of the original picture. Used like *delineavit* (see DEL., DELIN.) and *pinxit* (see P., PINX.).

INC., INCID., INCIDIT, INCISOR (Lat., incidit = has cut it) On a print, refers to the engraver or etcher when it follows a name. Used like *fecit* (see F., FE., FEC., FECIT) and *sculpsit* (see SC., SCULP., SCULPT., SCULPEBAT).

INCRUSTATION Decoration of architectural surfaces or decorative objects with colored inlays of contrasting materials. When done on wood, the process is called INTARSIA.

INDUSTRIAL ART See INDUSTRIAL DESIGN.

INDUSTRIAL DESIGN The application of AESTHETIC principles to the DESIGN of machine-made articles, with a canon of standards quite independent of those for handmade objects. Chiefly a phenomenon of the last hundred years, it was first espoused by members of the ARTS AND CRAFTS MOVEMENT. Also called industrial art.

INSTALLATION Coming into vogue in the 1970s, the term sometimes refers to outdoor sculptural ensembles but usually characterizes indoor, SITE-SPECIFIC painting, sculpture, or MIXED-MEDIA works. As one-time exhibitions, whether temporary or permanent, installations are unmarketable except in the form of photographs taken of the works. Walter De Maria's *Earth Room* occupies an entire room, which is filled to windowsill level with dirt. It is

permanently installed and is EARTH ART in the most literal sense.

INTAGLIO Term describing DESIGNS or forms carved or sunk into a surface, instead of standing out from it. A process used in gem carving as well as in the graphic arts, including ENGRAVING and ETCHING. See LINE ENGRAVING.

INTARSIA Decoration of a wood surface by inlaying a design in such materials as mother-of-pearl, metal, ivory, etc.

INTENSITY See COLOR.

INTERLACE Decoration formed of entwined, interwoven LINEAR elements. See ANIMAL INTERLACE, LACERTINE.

INTERNATIONAL STYLE An aspect of GOTHIC art of the late 14th and early 15th centuries characterized by a lyrical, NATURALISTIC treatment of subject matter, gently flowing lines, and pretty, delicate coloration. Also called international gothic style. In architecture, the clean-surfaced glass-enclosed style formulated at the BAUHAUS in the 1920s which has dominated commercial architecture since the 1950s. Mies van der Rohe, Philip Johnson, and Richard Neutra have been leading architects in the International style. Le Corbusier's *machines à habiter* (machines to live in), as he called the private homes commissioned early in his career, was a term meant to emphasize clean, precise, machine-like forms rather than a desire for mechanized living. But it also underlined modern architecture's obsession with functionalist forms.

INTIMISM The painting of intimate scenes, e.g., domestic interiors or objects associated with them. A type of GENRE practiced particularly by French painters like Pierre Bonnard and Edouard Vuillard.

INTONACO In FRESCO, the final coat of plaster on which the painter actually works, while it is still wet.

INTRADOS Inner surface of an ARCH. (*Fig. 6*)

ISOCEPHALY A method of composing groups of figures in such a way that all are shown at the same height, regardless of posture or purpose. Characteristic of classical Greek art.

ISOMETRIC PROJECTION In architectural drawing, a means of showing a building in three dimensions without FORESHORTENING. The horizontal lines are usually drawn at a thirty-degree angle, the vertical lines are parallel, and all lines are drawn to scale. Compare PLAN, ELEVATION, and SECTION.

ITALIANATE STYLE An American residential architecture style seen ca. 1840 to 1865. Fancifully adapted from Italian Renaissance palaces, the American version is typically of two or three stories with a low-pitched hip roof, formal balance of design, wide and bracketed eaves, and much interest in such FACADE details as window caps. Most examples have a CUPOLA or BELVEDERE. The innovation of cast-iron construction in the mid-19th century provided affordable, mass-produced Italianate FACADES such as those still found in the SoHo district of New York City.

J

JACOBEAN STYLE The style of architecture, interior decoration, and furniture associated with England and the reign of James I (1603–1625). In it classical elements are combined with STRAPWORK and northern European figural motifs.

JAMB FIGURE Sculptured figure attached to the jamb (the vertical part) of a medieval church portal. Also called column figure. (*Fig. 10*)

JAPONAISERIE (Fr., article of Japanese craft) In a specific sense, those items of Japanese creation that began to be imported into Europe in the 1850s and 1860s: WOODBLOCK PRINTS, textiles, PORCELAIN, fans, furniture, and metalwork. The influence of japonaiserie on the painting of the IMPRESSIONISTS is called japonisme.

JAPONISME See JAPONAISERIE.

JUBÉ See ROOD SCREEN.

JUGENDSTIL The German term for the style known elsewhere as ART NOUVEAU. Named after the unofficial organ of the movement in Germany, the magazine *Jugend*, founded in 1896.

JUNK SCULPTURE With DADA roots in the COLLAGES of Kurt Schwitters, which were created from trash collected from the streets, junk sculpture first

appeared in the United States in the 1950s works of John Chamberlain and Robert Rauschenberg. It is a type of ASSEMBLAGE sculpture in which the sculptor uses materials cast off by modern urban culture and reassembles them with little or no comment. Junk sculpture has affinities to ARTE POVERA in Italy and similar movements in other European countries where it took on more nostalgic tones.

K

KAKEMONO See MAKEMONO.

KEY PATTERN See MEANDER.

KEYSTONE The wedge-shaped stone at the center point of an ARCH regarded as locking the other stones of the arch into place. (*Figs. 6, 7*)

KINETIC ART Art that moves, driven by atmospheric forces (e.g., Alexander Calder's MOBILES) or by motors, magnets, etc. Retrospectively applied to sculpture in motion created since the 1920s, recent kinetic art includes machine "sculptures" by the ART COLLECTIVE Survival Research Laboratory.

KITSCH A strict dictionary definition describes kitsch as "something of tawdry design, appearance, or content created to appeal to popular or undiscriminating taste." By the 1960s POP ARTISTS were ushering in changed attitudes as they APPROPRIATED these once-denigrated mass-produced objects for use in their works. Contemporary artists like Jeff Koons continue to walk a fine line between the good taste of bad taste and outright bad taste. See POPULAR CULTURE.

KORE (pl., korai) In archaic Greek art, statue of a standing, draped maiden; counterpart to the male KOUROS.

KOUROS (pl., kouroi) A type of statue of a standing young man occurring in archaic Greek art. Kouroi are frontally disposed, bilaterally symmetrical, and the left foot is usually advanced.

KRATER A type of ancient Greek vessel with a broad body, wide mouth, and hemispherical base that was used to hold a mixture of wine and water. Often a field for decoration.

KYLIX (CYLIX) A wide, shallow Greek drinking cup with two handles set horizontally and with or without a slender stem. The inside of the bowl was a field for vase painting.

LACERTINE See ANIMAL INTERLACE.

LACQUER A resinous varnish that, when applied in several layers, attains a high polish. True lacquer comes from the Japanese lac tree. Characteristically oriental, lacquer work spread to Europe in the early 18th century. Usually decorated. See PYROXYLIN.

LANCET STYLE See EARLY ENGLISH STYLE.

LANCET WINDOW A tall and narrow window which comes to an acute point at its head. Commonly used in the 13th century.

LAND ART See EARTH ART.

LANTERN A superstructure atop a DOME, with windows on all sides. (*Fig. 5*)

LATIN CROSS CROSS with transverse arms and upper shaft of equal length, and shorter than the lower shaft. Used as the basis for Western European church PLANS.

LAY FIGURE A jointed wooden dummy of the human body used by painters and sculptors as a model on which to arrange drapery and clothing. Usually life-size and more elaborately jointed than a MANIKIN.

LEAN COLOR PIGMENT containing little oil. See FAT OVER LEAN.

LEAN SURFACE The MATTE SURFACE produced by painting with a minimum of oil; essential in UNDERPAINTING. See FAT OVER LEAN.

LETTRISM A phenomenon since the 1950s, lettrism is the juxtaposition of letters, words, signs, and pictographic symbols with visual effect as the primary concern and with the meaning (if any) of secondary importance. Concrete poetry is a form of lettrism, but here the verbal meaning is as important as the design. Also called typewriter art.

LIERNE In GOTHIC VAULTING, a RIB which connects structural, weight-bearing ribs to form part of a decorative, net-like design.

LIFE-ENHANCEMENT Term used by art historian Bernard Berenson to describe what he considered the primary function and role of art: the power to enrich, enhance, and extend the meaning of life.

LIGHT SCULPTURE Sculpture in which light sources (fluorescent and neon bulbs, incandescent bulbs, laser beams, and sunlight) are the primary MEDIUM or source of visual interest. Minimalist Dan Flavin, Chryssa, and Robert Whitman are three of the best-known light sculptors.

LIMNERS Untutored American artists who executed naive and literal portraits. Often itinerant, they worked mostly in the 18th and early 19th centuries.

LINE DRAWING Drawing in which the primary element of definition is line, as opposed to a BRUSH or WASH drawing.

LINE ENGRAVING An INTAGLIO ENGRAVING process in which the design is drawn by incising lines directly into a

metal plate with a BURIN; the burr is removed, leaving a clean groove to receive the ink, which is transferred to paper under the pressure of the press.

LINEAR Stylistic term used to describe a work of art in which CONTOUR, rather than masses of tones or colors, is the primary means of COMPOSITIONAL definition. Compare PAINTERLY.

LINEAR PERSPECTIVE The means of delineating three-dimensional objects on a PICTURE PLANE by rendering them in terms of receding planes. The simplest form is one-point PERSPECTIVE. (*Fig. 12*)

LINING See RELINING.

LINOLEUM BLOCK Linoleum glued to a block of hard wood and used as a surface on which to carve designs for RELIEF PROCESS prints.

LINTEL Horizontal architectural member which spans an opening.

LITERARY ART Art with its subject matter drawn from a text; illustration. Literary art is generally thought to be aesthetically superior to NARRATIVE ART. Many ROMANTIC painters, e.g., Eugène Delacroix and William Blake, worked in the literary tradition.

LITHOGRAPHY A PLANOGRAPHIC process that depends on the antipathy of grease to water. The design is drawn directly on a bed, traditionally of limestone, with a greasy CRAYON. The stone is wetted, then coated with an oily ink, which clings to the greasy design and is repelled by the wet areas.

LOADED BRUSH See IMPASTO.

LOCAL COLOR System of representing the COLOR of an object which begins with its hue and adds shade or lightness by the addition of black or white PIGMENT to give a more NATURALISTIC appearance. Pure or shaded local color was used almost exclusively until the late 19th century, when the IMPRESSIONISTS discovered that the brain blends contrasting hues into vibrant impressions of actual color. See COLOR and OPTICAL MIXING.

LOGGIA A porch open on one or more sides.

LOST WAX PROCESS See CIRE PERDUE.

"LOW" ART Comprises the "lesser" or "minor" arts, also known as the DECORATIVE or APPLIED ARTS. A more contemporary understanding of the term relates it to POPULAR CULTURE. Since the 1960s and the POP ART movement, artists have freely APPROPRIATED objects from everyday consumer culture for CONTENT and conceptual inspiration. Andy Warhol's infinitely reproducible silk screens of Marilyn Monroe, and Roy Lichtenstein's ironic imitations of melodramatic cartoons, challenge basic assumptions previously ascribed to "HIGH" ART, such as the uniqueness and seriousness of the artwork. The boundary between "high" and "low" art has faded in the contemporary art scene. Once-marginal artists, such as Keith Haring and his GRAFFITI artworks, were quickly commodified, and their works sold for large amounts of money.

LUMINISM American landscape style associated chiefly with the HUDSON RIVER SCHOOL. Luminist paintings are characterized by a fascination with water and light in landscape, by an absence of brush marks, and by masterful control of tonal gradations in ATMOSPHERIC PERSPECTIVE.

LUNETTE A window or painting of semicircular shape.

LUSTERWARE A Middle Eastern luxury item brought to Spain in the late 10th century. Muslim artisans produced iridescent CERAMIC GLAZES that appeared as metallic silver, copper, or gold. In the 15th century lusterware tiles and dinnerware were commissioned throughout Europe by princes, cardinals, and popes. Decorative elements included their heraldic emblems along with Moorish signs and symbols.

LYRICAL ABSTRACTION Although this term remains vague and is used differently by various writers, it generally refers to the so-called third generation of ABSTRACT EXPRESSIONISM, which developed in the early 1970s and was characterized by more sensuous and subjective abstract interpretations than those of the second generation of abstractionism with their geometric tendencies: POP ART, HARD-EDGE PAINTING, and MINIMAL ART, for example.

M

MACULATURE The weak impression that results when a print is made without re-inking the plate. Often used as a PROOF.

MAESTÀ A representation of the Madonna and Child enthroned and surrounded by angels and sometimes also by saints.

MAGIC REALISM Deriving from the metaphysical period of Giorgio de Chirico (see METAPHYSICAL ART) and related to SURREALISM, magic realism translates everyday experiences into disturbing images by curious juxtapositions of sharply painted elements. Balthus and Peter Bloom are magic realists. Also called precise realism, sharp-focus realism.

MAHLSTICK A long stick, padded at the end, which a painter rests on the canvas and uses to support his arm while he is painting important details.

MAJESTAS DOMINI Christ in Majesty, enthroned within a MANDORLA and surrounded by the symbols of the Evangelists.

MAJOLICA (It., maiolica) A type of tin-enameled EARTHENWARE said to have been made first in Majorca. Commonly refers to the richly painted ENAMELED POTTERY produced in Italy.

MAKEMONO Far Eastern painting on a long horizontal scroll; such a painting on a hanging vertical scroll is a kakemono.

MALERISCH See PAINTERLY.

MANDORLA An almond-shaped GLORY that surrounds the whole figure.

MANIÈRE CRIBLÉE See DOTTED PRINT.

MANIFESTO A term closely associated with the AVANT-GARDE MODERNISTS and used primarily during the 20th century. Often the work of writers rather than artists, manifestos were published to proclaim new or revolutionary movements that spanned the arts, as in the FUTURIST and SURREALIST manifestos.

MANIKIN A jointed LAY FIGURE, smaller than life-size and generally with fewer articulations than a lay figure.

MANNERISM Style of art and architecture that emerged in the period from ca. 1520 to ca. 1590, characterized by a reaction to the harmony of the HIGH RENAISSANCE, an ideal of virtuosity for its own sake, and a concomitant preoccupation with the ambiguous and discordant. Exemplified in the works of El Greco, Pontormo, Parmigianino, and (late) Michelangelo.

"MANNER OF," "STYLE OF" In describing a work of art, "in the manner/style of" refers to stylistic similarity to the artist named, but not necessarily direct influence. Compare "FOLLOWER OF," "CIRCLE OF," SCHOOL, WORKSHOP.

MANUSCRIPT A text written by hand, as an ancient scroll, a hand-lettered CODEX, and even a modern, unprinted book. When decorated with color illus-

trations called ILLUMINATIONS, such a work is an illuminated manuscript.

MAQUETTE A small model for an architectural project. See BOZZETTO.

MARQUETRY Inlay work, referring especially to furniture in which colored woods, shell, ivory, etc., are embedded flush with the surface. See INCRUSTATION, INTARSIA.

MARXISM Provides an analysis exposing the social relations that operate in the production of material goods. Marxist art critiques demystify the relationship between artists and patrons, demonstrating who supports whom and why. By exposing the market forces weighing on artists, such an analysis demonstrates how both AESTHETIC and monetary value may be ascribed to artworks (see COMMODIFICATION). As a political ideology, it has influenced the MODERN MURALISTS Diego Rivera and José Clemente Orozco as SOCIAL REALISTS. Recently, Hans Haacke has created Marxist artworks exposing pervasive corporate sponsorship in the art world.

MASTABA An Egyptian burial chamber built of stone in the form of a low, truncated pyramid.

MATIÈRE (Fr., material) In painting, the canvas and paint; in sculpture, the substance to be carved or molded.

MATTE SURFACE A dull, flat surface without gloss.

MEDIA ART When "media" refers to the mass media rather than to a particular art MEDIUM, this term refers to a trend in art production that involves the REPRESENTATION of representations, i.e., the depiction or DECONSTRUCTION of mainstream images of those

societal groups traditionally marginalized and depicted as stereotypes (e.g., African-Americans, women, Hispanics, Asian-Americans, gays and Lesbians). It has also come to include works appearing in mass media spaces, such as those usually reserved for advertising. Jenny Holzer's FAKE television commercials on MTV are directed to an audience that might never enter a museum.

MEDIUM (pl., media) The physical material or materials of which a work of art is made: OIL PAINT, clay, ink, PASTEL, wood, concrete, etc. Also used synonymously with VEHICLE to mean the diluent in which PIGMENT is suspended.

MEGARON Type of dwelling in Mycenaean architecture, with a porch and a main chamber having a hearth in the center. Specifically, the ceremonial hall or men's hall of a Mycenaean palace.

MENHIR Huge block of natural or crudely worked stone; megalith. See MONOLITH, DOLMEN.

MESOPOTAMIAN ART See ANCIENT NEAR EASTERN ART.

METAL CUT A RELIEF PROCESS for producing prints which differ from WOODCUT mainly in the use of a metal plate instead of a block of wood. Introduced about 1500, metal cut never found wide use.

METAPHYSICAL ART The movement *pittura metafisica* founded by Giorgio de Chirico, Carlo Carrà, and F. de Pisis in 1917. Now seen as a bridge between certain forms of ROMANTIC painting and SURREALISM. Metaphysical painters created haunting images with dreamlike fusions of reality and unreality. The movement ended by 1920.

MÉTIER A particular subject in which an artist specializes.

METOPE Rectangular panel found alternating with TRIGLYPHS on the FRIEZE of a Greek Doric ENTABLATURE. (*Fig. 1*)

MEZZO RILIEVO Medium-high RELIEF.

MEZZOTINT A process of INTAGLIO ENGRAVING commonly practiced in the 18th century to reproduce the tonal effects of painting. A metal plate, usually copper or steel, is roughened with a rocking tool which makes indentations and raises a BURR. The burr is scraped away where lighter tones in the design are desired.

MIGRATION ART See GERMANIC ART.

MILLEFIORI (It., a thousand flowers) Glassmaking technique in which rods of colored glass are fused, after which the bundled mass is cut transversely. The flower-like sections are used for beads and also embedded in clear glass for decorative effects.

MINARET A tall, slender tower attached to a mosque and from which the muezzin calls people to prayer from one of its several balconies. It may be either rectangular or cylindrical in PLAN. Seville's Giralda tower (12th century) was once a minaret, later redecorated in Christian styles.

MINIATURE PAINTING In general, painting of a small scale. Specifically, portraits on parchment or ivory and also illustrations in MANUSCRIPTS—which are called ILLUMINATIONS. Miniature portraits were painted from the Renaissance onward.

MINIMAL ART The most reductive of all the POST-PAINTERLY ABSTRACTION movements. Minimal painting—rejecting space, texture, subject matter, and atmosphere—relies solely on simple form and flat color for effect. Minimal sculpture, usually of monumental size, is equally free of personal overtones, rely-

ing on the simplest geometric forms and the power of its presence for effect. Artists identified with minimal art include Barnett Newman, Ellsworth Kelly, Dan Flavin, Donald Judd, Agnes Martin, and Larry Bell.

MINOAN ART See AEGEAN ART.

"MINOR" ARTS Generally, all art forms except the major ones of painting, sculpture, and architecture. See "LOW ART," DECORATIVE ARTS, APPLIED ARTS.

MIXED MEDIA The use of several different materials in the same work of art. Also, performances which combine such elements as song, dance, film, sound, light, spoken word, etc. The term multi-media is synonymous with mixed media when applied to a performance.

MOBILE A KINETIC sculpture that consists of forms connected by wires or rods and wire. Because it hangs free, it is set in motion by air currents. Devised in 1932 by Alexander Calder.

MOCK DRAPERY Wall decoration of painted curtains or draperies.

MODELLO See SKETCH.

MODERN ART In strict historical terminology, modern art began in the middle of the 19th century with the REALISM of Gustave Courbet. At that time, art began to free itself from the strict requirements of subject matter and developed increasingly toward preoccupation with FORM. In general, it also repudiated many of the techniques of pleasing the viewer devised by past CANONICAL artists.

MODERNISM The philosophy of MODERN ART. Nineteenth-century industrialization resulted in societal changes

which radically altered institutions of patronage for artists. With the rise of museums and an expanding commercial art market, artists were freer to experiment in modes of expression. ART FOR ART'S SAKE was the common credo as this AVANT-GARDE determined their own CONTENT, FORM, and MEDIUM. Movements and styles abounded, including: CUBISM, CONSTRUCTIVISM, EXPRESSIONISM, DADA, SURREALISM, ABSTRACT EXPRESSIONISM, and MINIMALISM. Modernist art criticism was centered on SIGNIFICANT FORM. Painting (especially ABSTRACT EXPRESSIONISM) was thought to progress toward purity in its refinement of color and flatness. The DECONSTRUCTIVE critique of such FORMALIST emphasis exposed the "impurity" of meaning, that is, the possibility of multiple interpretations and a relativization of value judgments. This decentering expanded the theoretical and artistic modes of basic importance to POSTMODERNISM. See INTERNATIONAL STYLE.

MODULAR Designed or constructed according to a standardized scale or parts, as in prefabricated building construction and furniture systems.

MODULE In classical architecture, half the diameter of a COLUMN at its base; by extension, any standard unit of measurement in architecture.

MOLDING Strip of material, usually of stone or wood, which may be shaped into concave, convex, projecting, or sunken forms to be a decorative edging for doors, windows, CORNICES, panels, etc.

MONOCHROMY That which is completed in only one COLOR or shade. See GRISAILLE.

MONOGRAPH A catalogue of artworks comprising one artist's production. Compare CATALOGUE RAISONNÉ.

MONOLITH A single block of stone carved into a PILLAR, statue, or COLUMN. Large size is implied.

MONOTYPE A print made by a PLANOGRAPHIC process in which an impression—usually only one—is taken from a metal plate on which a design has been made in oil color or printer's ink.

MONTAGE A picture formed by applying separate images in parts or layers to form a total image. Similar to COLLAGE. In photomontage, photographs, often incongruous, are juxtaposed.

MOSAIC The technique of decorating walls, floors, etc., with designs formed by embedding small cubes (tesserae) of glass, CERAMIC, or marble in a fine cement. Though known by ancient artists, it was fully developed only in BYZANTINE and Roman art.

MOSAN Term referring to art produced in the 12th and early 13th centuries in the valley of the Meuse River, which rises in northeastern France and flows through the Low Countries.

MOZÁRABE STYLE Describes a tradition of art developed by the Christians (mozárabes) who lived in those parts of Spain under Muslim rule from the 8th to the 15th centuries. The Mozárabe style was primarily associated with church architecture and was often characterized by the horseshoe ARCH, a holdover from VISIGOTHIC times.

MS., MSS. Abbreviations for MANUSCRIPT, manuscripts.

MUDÉJAR STYLE During the Christian reconquest of Muslim Spain (8th–15th centuries), many Muslims (mudéjares) remained in the newly conquered Christian territories. The resulting architectural style, which predominated from the 12th to 16th centuries, was

an amalgam of ROMANESQUE and GOTHIC with Arabic. Characteristics of the latter include geometric designs for ornamentation as well as the use of CERAMIC, plaster, and brick materials.

MULLION The vertical element or elements that divide a window into two or more lights.

MULTICULTURALISM This movement focuses primarily on changing traditional CANONS throughout the humanities. With the expansion of canonical traditions and exposure of students at all levels to artists, writers, and historical movements previously marginalized in general bodies of knowledge, the next generation is expected to have a better grasp of an increasingly diverse society in a world in flux. In the realm of art in the United States, this has resulted in a greater emphasis on and interest in non-Western art and on works produced in communities without previous access to museum and gallery exposure (e.g., African-Americans, Hispanic-Americans, Asian-Americans, women, gays, and lesbians).

MULTI-MEDIA See MIXED MEDIA.

MULTIPLES Works of art theoretically made in unlimited numbers—in contrast with works made in traditional EDITIONS—which are slightly altered in style from their ORIGINALS. Multiples by Alexander Calder, Claes Oldenburg, and others were introduced in the 1960s, when they were promoted by private art galleries.

MUNTIN Sash bar in a panel door. Sometimes incorrectly used for MULLION.

MURAL A large painting or decoration applied directly on a wall surface or completed separately and later affixed to it. Early Italian RENAISSANCE examples

include church FRESCOES, while in this century
EXPRESSIONIST and SOCIAL REALIST murals have been
commissioned for public buildings in postrevolu-
tionary Mexico.

MUSEUM WITHOUT WALLS Phrase describing the illustrations
and reproductions that today make works of art
widely available. Introduced by André Malraux in
his book *The Voices of Silence*, 1954.

MUTULE One of a series of square blocks that project above
the TRIGLYPH on the underside of a Doric CORNICE.

MYCENAEAN ART See AEGEAN ART.

N

NABIS, LES (Heb., prophet) Those French artists, influenced by Gauguin's approach, who exploited the decorativeness and surface qualities of their paintings. They tended toward fantasy in their subject matter, under the influence of the SYMBOLIST MOVEMENT. Edouard Vuillard, Pierre Bonnard, and Aristide Maillol were Nabis early in their careers.

NAIVE ART Primarily understood as works produced by artists who lack formal training, although trained artists may deliberately affect a naive style. The term most clearly describes such early-20th-century artists as the Douanier Rousseau, whose childlike, non-naturalistic paintings completed in bright colors influenced early modern artists. Their apparent affinity with non-Western art and their bold expressiveness made them appealing to the early MODERNISTS searching for new forms of expression. See "OUTSIDER" ART.

NARRATIVE ART Implies the representation of story elements synthesized into various or possibly single images. HISTORY PAINTING, for example, depicts scenes from famous historical events as well as biblical and classical themes. Rejected for twenty years in favor of ABSTRACT ART, narrative had made its return by the 1970s. Visual narrative modes may involve painting, PERFORMANCE, and VIDEO. Ida Applebroog paints comic strips with FEMINIST undertones, while Duane Michals augments series of photographs with written text.

NARTHEX A vestibule placed transversely between the NAVE and the west entrance of a church. (*Figs. 3, 4*)

NATURALISM The precise representation of an object—true to life in every detail and irrespective of subject matter or time period. Compare REALISM.

NAVE Technically, the part of a church west or forward of the CROSSING, but usually applied only to the center aisle of that part. (*Figs. 3, 4*)

NAZARENES A group of German painters active in Rome in the early 19th century who advocated an art based on the inspiration of primitive Christianity, even to the point of reviving FRESCO painting. The Nazarenes are regarded as ROMANTICS; they consciously rejected contemporary NEOCLASSICISM. The best known is Johann Friedrich Overbeck.

NECROPOLIS Burial place or cemetery.

NEOCLASSICISM Art and architecture of the period from ca. 1770 to ca. 1830 when, under the stimulus of the renewed enthusiasm for classical civilization, artists rejected the highly ornate ROCOCO style and turned to subjects and motifs from classical antiquity. The style is characterized by clarity, balance, and restraint. Architectural examples include many public buildings in Washington, D.C., while in painting Jacques-Louis David drew on ancient morals to suit postrevolutionary circumstances in France. Used generally, neoclassicism can mean any manifestation of a return to classical sources.

NEO-EXPRESSIONISM Term used to describe the primarily German and Italian EXPRESSIONIST art revival of the 1970s and early 1980s. Rejecting both CONCEPTUAL and MINIMALIST modes, the neo-expressionists returned to gestural, FIGURATIVE painting. Often steeped in the past, A. R. Penck's symbolism refers

to the repressed in German history, while in the United States, Sue Coe's violent images more directly confront a dysfunctional social reality.

NEOGOTHIC See GOTHIC REVIVAL.

NEO-IMPRESSIONISM An outgrowth of IMPRESSIONISM pioneered by Georges Seurat and based on the scientific juxtaposition of touches or dots of pure color. The brain blends the colors automatically in the involuntary process of OPTICAL MIXING. Other neo-impressionists include Camille Pissarro and Paul Signac. Also called pointillism, divisionism.

NEO-PLASTICISM Also called DE STIJL. An influential movement in painting, sculpture, and architecture, founded by Piet Mondrian and Theo van Doesburg in 1917. It represents a logical extension of CUBISM, in which the action of color and FORMS (Mondrian's interpretation of plasticism) was reduced to utter simplicity by strict adherence to simple geometric shapes. In this way, art was intended to escape the particular and achieve harmonious, universal expression.

NEO-ROMANTICISM A minor movement that paralleled SURREAL-ISM but concentrated on more lyrical subjects, particularly man's environment and emotions. The key figures were Christian Bérard, Eugene Berman, and Pavel Tchelitchew.

NET VAULTING Form of late GOTHIC VAULTING in which the decorative LIERNE RIBS assume an intricate, net-like pattern.

NETSUKE Japanese belt toggle often made of ivory and carved in the form of an animal or animals.

NEUE SACHLICHKEIT See NEW OBJECTIVITY.

NEW OBJECTIVITY (Ger., Neue Sachlichkeit) Chiefly associated with German art, it was a manifestation of a reaction against EXPRESSIONISM. Called Neue Sachlichkeit first in 1923, the movement was a sometimes gritty form of SOCIAL REALISM and included artists George Grosz and Otto Dix.

NEW REALISM (Fr., le nouveau réalisme) Once understood as a term for the European counterpart to American POP ART, it is currently used as an umbrella term for FIGURATIVE alternatives to the NON-OBJECTIVE ART of the 1940s and 1950s. Examples from the 1960s include probing portraits by Alice Neel and nudes by Philip Pearlstein.

NEW SUPERREALISM See POP ART.

NEW YORK SCHOOL See ABSTRACT EXPRESSIONISM.

NIELLO A black alloy of lead, silver, copper, and sulphur, used to ornament metal objects. Designs incised on the objects are filled with the alloy, which is then fused with the metal by means of heat. Also, the objects so decorated. Chiefly a late medieval and early Renaissance process.

NIMBUS A GLORY in the form of a gold disc or a circle of light around the head of a sacred personage in art.

NOCTURNE A night scene.

NON-OBJECTIVE ART An umbrella term covering such styles in MODERN ART as ABSTRACT EXPRESSIONISM, CLASSICAL ABSTRACTION, CONSTRUCTIVISM, L'ART INFORMEL, and many others. Basically, it is a pure form of ABSTRACT ART that makes use of color, FORM, and texture with absolutely no recognizable subject matter.

NORTHERN RENAISSANCE ART Art north of the Alps in the first half of the 16th century. Sometimes extended to include the essentially late GOTHIC Netherlandish painting of the 15th century because of its interest in certain aspects of REALISM.

NOUVEAU RÉALISME, LE See NEW REALISM.

OBELISK A tall, four-sided freestanding PILLAR tapering to a pyramidal terminus. Obelisks were placed at the entrances of Egyptian temples, and continue to be a favored shape for monuments in the Western world.

OBJET D'ART (Fr., art object) A work of art of small size, as a MINIATURE PAINTING, statuette, vase, snuffbox. Compare BIBELOT.

OCTAVO A book usually measuring between 5 by 8 inches and 6 by 9 1/2 inches, which is composed of sheets folded into eight leaves.

OEUVRE (Fr., work) An artist's total production.

OILING OUT A process of rubbing a drying oil (such as linseed oil) over those colors in a painting which have lost their luster. Although brilliance is restored for a while, the ultimate effect is to darken them further.

OIL PAINT Paint made of PIGMENT mixed with a drying oil, linseed oil being the most traditional.

OLD MASTER Traditionally, a distinguished painter, sculptor, or draftsman active before 1700. Now being used as well for recognized masters of the 18th century. See CANON.

ONE-IMAGE ART. See SYSTEMIC PAINTING.

OP ART (optical art) Painting based on optical illusion, perception, and their physical and psychological effects. A very popular movement of the 1960s, of which two leading exponents are Richard Anuskiewicz and Bridget Riley. Op art is invariably NON-OBJECTIVE and usually HARD-EDGE. Also called retinal painting and perceptual abstraction.

OPISTHODOMOS An open porch at the back of a Greek temple, corresponding to the PRONAOS at the front. (*Fig. 2*)

OPTICAL MIXING The involuntary mixing of juxtaposed COLORS by the eye and brain. Thus, at a certain distance, juxtaposed dabs of red and yellow PIGMENT produce the sensation of orange. The colors seen by optical mixing appear clearer and more brilliant than those obtained by mixing colors on a PALETTE.

OPUS ANGLICANUM English embroidery of the 13th and early 14th centuries. Virtually all surviving examples are for ecclesiastical use. Also called opus anglicum.

ORDER See CLASSICAL ORDER.

ORIGINAL Refers to works considered to be AUTHENTIC examples of the works of an artist or epoch, rather than reproductions or imitations. In the case of OLD MASTER paintings, the term is generally exclusive of those created in the "STUDIO OF" an artist, but complications arise for WORKSHOP paintings where there is evidence of the master's hand. As a result of COMMODIFICATION, reproductions of famous works in the form of photographs, postcards, and posters have reached greater audiences than the originals ever could. See ORIGINALITY.

ORIGINALITY Pertains to a work thought of as non-derivative—one that has been created indepen-

dently of other STYLES or movements. Along with
the concept of AUTHORSHIP, it is essential to under-
standing the role of the AVANT-GARDE in MODERNISM.
An important element of art history has been the
documentation of individual artists and works per-
ceived as innovative and original. The prevalence
of photography, VIDEO, APPROPRIATION, and reap-
propriation as well as other reproductive tech-
niques has contributed to the de-emphasis of
originality. A basic tenet of POSTMODERNISM is, in
fact, the myth of originality.

ORMOLU Gilded bronze mount used in decorating certain
styles of furniture. Also, an article made or deco-
rated with such mounts.

ORPHISM An aspect of CUBISM, sometimes called Orphic
cubism, explored by Robert Delaunay beginning
about 1912. The primacy of color and color rela-
tionships in the making of the picture was the
keynote, although Delaunay himself alternated
during this phase between pure ABSTRACTION and
quasi-REPRESENTATIONAL forms.

OTTOCENTO (It., eight hundred) The 19th century, used espe-
cially when referring to Italian art and literature of
that century.

OTTONIAN ART German art of the 10th and early 11th cen-
turies. Strong BYZANTINE influences replaced the
EARLY CHRISTIAN prototypes of the preceding
Carolingian period. Still, synthesis with the native
German tradition is more complete than in
CAROLINGIAN ART.

"OUTSIDER" ART Once a virtual synonym for NAIVE ART, it is
now more current when referring to the work of
contemporary, untrained artists. Sometimes its
focus is restricted to describe works by those out-

side mainstream society, such as the mentally ill, or by rural artists working apart from urban art centers.

OVERPAINTING A layer of paint applied over an underlayer.

P

P., PINX., PINXIT, PICTOR (Lat., pinxit = has painted it) Refers to the artist of the ORIGINAL picture when it follows a name on a painting or, more usually, a PRINT. Used like *delineavit* (see DEL., DELIN.) and *invenit* (see IN., INV., INVENIT, INVENTOR).

PAGODA Temple or tower found in India, China, and Burma. Typically, this polygonal tower includes projecting roofs over the individual stories. The numerous pagodas built in 18th- and 19th-century Europe are examples of CHINOISERIE.

PAINTERLY A term (*malerisch*) first used by Swiss art historian Heinrich Wölfflin to describe one of two stylistic qualities possible in a painting: LINEAR and painterly. The linear style represents forms in terms of CONTOUR; the painterly by COLOR and tonal relationships that are not sharply delineated. In general, RENAISSANCE painting is linear, BAROQUE is painterly.

PALETTE The surface on which an artist sets out and mixes PIGMENTS. Also, the range of COLORS used by an artist. See also SPECTRUM PALETTE.

PALLADIAN In the classicistic architectural style of Andrea Palladio (Italian, 1508–1580). Chiefly an English development of the 17th and 18th centuries, Palladian architecture is characterized by symmetry and by the elaborated adaptation of classical architectural elements.

PALMETTE Ornament motif based on the palm leaf. Seen in Egyptian and especially Greek classical ornament.

PANEL PAINTING A painting on wood or some comparatively hard surface, such as copper.

PANORAMA A continuous painting, usually a landscape, around the walls of a room or rolled on a cylindrical drum.

PANTHEON Strictly, a temple dedicated to the gods. The most famous is Rome's huge, circular domed Roman temple of about 25 B.C., which is called the Pantheon.

PAPIERS COLLÉS (Fr., pasted papers) Pictures created from cut and glued pieces of paper, cardboard, newsprint, playing cards, etc. These objects function in two ways: they REPRESENT (i.e., constitute an image of something new) while they also continue to present themselves as FOUND OBJECTS. This TROMPE L'OEIL technique was first employed by CUBIST Georges Braque in 1909. See COLLAGE.

PARERGON A detail subordinate to the main subject or theme of a picture, e.g., a glimpse of a landscape behind a portrait head.

PARQUET A method of preventing warping of wood panels by reinforcing them at the back with battens. Also, flooring made of thin wood blocks laid in geometrical designs and glued to the floorboards.

PASSAGE A term used when referring to a certain area of a painting. Also used to describe the transition from one tone to another, or the use of a special technique in a picture, or an area OVERPAINTED by someone other than the ORIGINAL artist.

PASTEL A picture executed with CRAYON sticks formed of colored powders mixed with gum tragacanth. Often done on tinted papers. Also called pastel painting.

PASTICHE A work of art created in the STYLE—or with the motifs—of another artist, or even of several artists, but not faked. Also, a FAKE made by deceptively combining known motifs of a master. See APPROPRIATION.

PASTOSE Thickly painted. See IMPASTO.

PATINA Greenish incrustation on the surface of old bronze. By extension, all forms of mellowing with age.

PATIO An open-air, inner courtyard often surrounded by a covered COLONNADE leading to interior rooms. Typical of Spanish and Latin American architecture.

PATROON PAINTER One of a mostly anonymous group of portraitists who painted the Dutch merchants of early New York (ca. 1675–1750) in a flat, NAIVE style. Patroon is Dutch for patron.

PEDIMENT In classical architecture, the triangular GABLE under the low-pitched roof of a building. Often decorated with sculpture. Such triangular areas are found over doors and windows as well as over PORTICOS. Loosely, any triangular field. (*Fig. 1*)

PELLICLE The thin skin, or film, which forms as OIL PAINT dries.

PENDANT An architectural ornament suspended from extended members. In GOTHIC architecture, it is a BOSS at the terminal of lowered RIBS. In wood architecture, it is a decorative terminal on dropped wood members at the end of an overhanging peak of a GABLE roof. Also, one of a pair

of paintings, sculptures, etc., which were conceived and executed as related, interdependent works.

PENDENTIVE One of the curved triangular sections of VAULTING springing from the corners of a base, which supports a DOME and effects the transition between the square base and the round dome. (*Fig. 5*)

PENSIERO See SKETCH.

PENTIMENTO (It., regret; pl., pentimenti) An alteration made by an artist while in the process of painting which later shows through.

PERCEPTUAL ABSTRACTION See OP ART.

PERFORMANCE ART The execution of a premeditated work of art before a live audience. CONCEPTUAL activity was primary in the performance element of a number of 1960s movements, among them: BODY ART, PROCESS ART, HAPPENINGS, STREET WORKS, etc. The 1980s saw the "crossover" of performance artists like musicians Laurie Anderson and David Byrne.

PERGOLA An outdoor walkway lined with COLUMNS and covered with beams upon which vines and other plants are trained to grow.

PERISTYLE Covered court enclosed on all sides by a COLONNADE. Occurs in temples, CLOISTERS, and domestic architecture.

PERMANENT PIGMENT PIGMENT whose susceptibility to deterioration under certain atmospheric conditions, in normal light or in proximity to other colors, is minimal. Compare FUGITIVE PIGMENT.

PERPENDICULAR STYLE The final phase of English GOTHIC architecture (ca. 1360–1550), notable for its emphasis

on vertical design in the TRACERY. Also called recti-
linear style.

PERSPECTIVE The technique of representing three-dimensional
objects on a two-dimensional surface, so that they
seem to appear as in nature. See LINEAR PERSPECTIVE
and ATMOSPHERIC PERSPECTIVE. (See *Fig. 12*)

PÉTARD A work of art calculated to attract attention through
the oddity of its color, COMPOSITION, or subject
matter.

PHOTOMONTAGE See MONTAGE.

PHOTO-REALISM REALIST works involving extreme, uniform,
and impersonal reproduction of detail. In painting
the results were almost photographic (the paint-
ings of Chuck Close were, in fact, reproduced
from photographs). Often the effect created was
of a certain unreality. Duane Hanson's casts from
models include real clothing, props, and body
hair. As a movement, photo-realism was centered
primarily in the United States, but it was also
strong in Western Europe from the late 1960s into
the 1970s.

PIANO NOBILE The principal story of an Italian palazzo,
raised one floor above street level.

PICTURE A painting or pictorial representation. Commonly
used by the British, the term is often mistakenly
thought by Americans to be an uncultivated word
for painting.

PICTURE PLANE The frontal boundary of a painting, which can
be thought of as similar to a plate of glass behind
which pictorial elements are arranged in depth.
ABSTRACT EXPRESSIONISTS worked directly on the
plane, unconcerned with recession in depth.
(*Fig. 12*)

PICTURESQUE A concept of beauty characterized by irregularities of DESIGN, by deliberate rusticity, and even a cultivated pursuit of nostalgia-inspired forms, which found expression first in paintings of the 18th century and eventually in architectural styles of the 19th century, notably GOTHIC REVIVAL and, in America, ITALIANATE.

PIER. Massive solid masonry that functions as a vertical structural support. Also, often used to designate ROMANESQUE and GOTHIC PILLARS of noncylindrical form. (*Fig. 6*)

PIETÀ A representation of the Virgin Mary holding the body of the dead Christ. Occasionally, other mourning figures are included.

PIGMENT Colored matter, either mineral or organic, that is mixed with a VEHICLE to make paint. Depending on its physical and chemical composition, it may be opaque, translucent, or transparent, and either PERMANENT or FUGITIVE.

PILASTER Shallow, flat, upright architectural member attached to a wall; structurally a PIER but ornamented like a COLUMN, with base, shaft, and CAPITAL. Pilasters usually project about one-third of their width from the wall.

PILLAR Vertical structural member supporting a load. Narrow in proportion to its height, it may be square, oblong, polygonal, or round in cross section (a COLUMN is always round).

PINNACLE Small decorative turret crowning spires, BUTTRESSES, etc., in GOTHIC architecture. (*Fig. 9*)

PITTURA METAFISICA See METAPHYSICAL ART.

PLAN A drawing of a building or site that represents the structure as if a horizontal cut were made close to the ground. Doorways, windows, VAULTS, and other openings are usually indicated. Compare SECTION, ELEVATION, and ISOMETRIC PROJECTION.

PLANOGRAPHY Process of printing from a flat surface either by offset or directly. LITHOGRAPHY and ALGRAPHY are planographic processes.

PLASTIC Describing something molded or modeled. Compare GLYPTIC.

PLASTIC FORM Form in three dimensions, as sculpture, pottery, architecture.

PLATE MARK On ETCHINGS and ENGRAVINGS, the rectangular indentation surrounding the image, produced during the printing process by the pressure of the metal plate on the dampened paper.

PLATE TRACERY Early form of GOTHIC TRACERY in which decorative openings are cut directly through the window wall.

PLATERESQUE (Sp., platero = silversmith, thus "silversmith-like"). An early-16th-century style that combines GOTHIC, MUDÉJAR, and RENAISSANCE elements pertaining to FACADE decoration in architecture. They include the pointed ARCH, GROTESQUE decoration, heraldic emblems, and the use of classical COLUMNS. The Moorish legacy manifests itself as intricate decoration covering almost all available surfaces.

PLEIN AIR, EN See PLEINAIRISM.

PLEINAIRISM (Fr., en plein air = in the open air). A movement allied to the French salon tradition of the late 19th

century which sought NATURALISM through skillful handling of atmospheric effects. Pleinairism was attempted in the studio and was achieved not by separation of colors and broken brushwork (as with some IMPRESSIONISTS, who worked out of doors), but by a luminous PALETTE (use of bright colors) and careful drawing. Jules Bastien-Lepage was the leading exponent.

PLINTH Square member on which a COLUMN or statue rests; a narrow rectangular platform of stone.

POCHOIR (Fr., stencil) The French term for STENCILING, which the French have especially favored as a technique of book illustration.

POINTILLISM See NEO-IMPRESSIONISM.

POLITICALLY CORRECT Entered common parlance in the 1980s via the intense cultural debates taking place on college and university campuses. Used in the mass media to describe diverse literary, artistic, and academic works that challenge traditional notions of identity (race, gender, class, and sexuality), CANON, and cultural mythmaking.

POLYCHROMY Refers to sculpture executed in various colors. From ancient times (conventional colors) and through the Middle Ages (more or less naturalistic colors), most sculpture was painted. Spain has a particularly strong tradition of polychromatic and gilt sculpture.

POLYMER TEMPERA A widely used synthetic painting medium, usually with a base of polyvinyl acetate or acrylic resin. It is water compatible, adheres to most surfaces, and dries quickly with no change in color.

POLYPTYCH Technically, a work of art comprising two or more panels. However, since the terms DIPTYCH

(two panels) and TRIPTYCH (three panels) are widely used, the word polyptych is usually used for a work of more than three panels, nearly always an ALTARPIECE.

POP ART With origins in the FOUND OBJECTS and READY-MADES of DADA and SURREALISM, this mostly American and British phenomenon of the 1960s drew its imagery from POPULAR CULTURE and employed the HARD-EDGE techniques and colors of commercial illustration. Its chief American protagonists, Andy Warhol, Roy Lichtenstein, and Claes Oldenburg, celebrated everyday consumer culture as a reaction against the disengagement of ABSTRACT EXPRESSIONISM. Pop art's playful and sometimes ironic approach was an important precursor to POSTMODERNIST works of the 1980s and 1990s. See KITSCH.

POPULAR CULTURE Nineteenth-century industrialization fueled the growth of an increasingly influential bourgeois class in need of more accessible diversions than those of their aristocratic counterparts. "Low" culture (as popular culture is better known) manifestations such as vaudeville, early film, radio, and later television, jostled with opera, theater, and ACADEMIC painting. But the popular success of these new cultural forms was rarely cultivated by MODERNIST artists, whose works were appreciated by a small elite. *Life* magazine's 1950s photo spread on the ABSTRACT EXPRESSIONIST Jackson Pollock and Andy Warhol's silk screens of soup cans signaled unprecedented fusions between "HIGH" and "LOW" ART and the transition to the POSTMODERN age. See CAMP, KITSCH.

PORCELAIN Hard, dense, white, and translucent CERAMIC material invented in China between 600 and 900 A.D. and reinvented in Europe in 1708. Regarded as the most refined of all ceramic wares.

PORTICO A structure attached to a FACADE and serving the purpose of a porch which consists of a roofed space—either open or partly enclosed—supported by COLUMNS and often with a PEDIMENT. Derived from classical architecture, it has been a standard feature of all NEOCLASSICAL architectural styles.

POST-IMPRESSIONISM A covering term that usually refers to the art of Paul Cézanne, Vincent Van Gogh, and Paul Gauguin. Building on works of the NEO-IMPRESSIONISTS, these artists rejected the importance given to NATURALISM and the depiction of momentary effects in IMPRESSIONISM. First used by English art theorist Roger Fry.

POSTMODERNISM Not a STYLE, SCHOOL, or singular AESTHETIC, but a cross-disciplinary, philosophical term with origins in literary criticism. Postmodernism reflects dissatisfaction with the FORMALIST emphasis of late MODERNISM; the debate continues as to whether it reflects an actual break or, instead, modernism's capacity for evolving self-critique. Of primary importance to postmodernism is DECONSTRUCTIVE criticism, a multifaceted approach that may include aspects of FEMINIST, MARXIST, SEMIOTIC, and psychoanalytic analyses. Building on innovations from POP, CONCEPTUAL, and feminist art, postmodern artists share a desire to question notions of subjectivity, ORIGINALITY, and AUTHORSHIP as well as the role of COMMODIFICATION in art production. Employing such devices as repetition, APPROPRIATION/ REAPPROPRIATION, and PASTICHE, these artists directly engage in aspects of "HIGH" and "LOW" ART and culture.

POST-PAINTERLY ABSTRACTIONISTS A term coined by American critic Clement Greenberg to describe a group of ABSTRACT artists working in the 1960s whose paintings and sculptures use large fields of a clear,

unbroken, and often lucid color and relatively impersonal technical execution. PAINTERLY is used in art historian Heinrich Wölfflin's sense to suggest the ABSTRACT EXPRESSIONISTS and their followers, whose personal mark is left by their brushwork and gestural drawing. The term covers COLOR-FIELD and HARD-EDGE PAINTING, MINIMAL ART, and SYSTEMIC PAINTING, and other movements in a similar spirit.

POSTER PAINT An opaque WATERCOLOR, relatively FUGITIVE and inexpensive. Also called powder color, poster color.

POTTERY General term for a variety of CERAMIC WARES which are made of relatively porous clays fired at low to moderate temperatures. Includes EARTHENWARE, STONEWARE, and RAKU.

POUNCING A method of transferring the outline of a CARTOON or drawing onto a surface. Holes are pricked along the lines of the cartoon, which is then placed on the painting surface. A fine powder (pounce) is forced through the holes, leaving on that surface a series of dots reproducing the design of the cartoon.

POUPÉE, À LA A technique of color ETCHING and ENGRAVING in which colored inks are applied to the plate with rolls of paper or cloth before printing. Late-17th-century Dutch discovery.

POUSSINISME See RUBÉNISME.

POWDER COLOR See POSTER PAINT.

PRAYER RUG Kind of oriental rug used for the kneeling prayers of devout Muslims. Its design has borders or decoration—often in the form of arches—that recalls the prayer niche of the mosque.

PRE-COLUMBIAN ART The art of the Americas before 1492.
Includes North American Indian art.

PRE-RAPHAELITE BROTHERHOOD A short-lived association
(1848–ca. 1854) of like-minded English artists
(Dante Gabriel Rossetti, John Everett Millais,
Holman Hunt, and others) who, like the German
NAZARENE brotherhood, strove to recapture the
direct religiosity of pre-Renaissance painting—
Raphael being singled out as representing the
"overly scientific" development of RENAISSANCE ART.
Their carefully limited subject matter involved sym-
bolism, and clear color had a lingering influence
on Victorian painting after the formal dissolution
of the brotherhood.

PRECISE REALISM See MAGIC REALISM.

PRECISIONISM A REALISTIC, even photographic, style, on which
the geometric analysis and economy of detail
introduced by CUBISM made a significant imprint.
Precisionist works often depict industrial and tech-
nological prowess idealistically. The style was
practiced by a number of American artists work-
ing in the 1920s, including Stuart Davis, Charles
Demuth, and Charles Sheeler. Also called immac-
ulate painting, cubist-realism, cubo-realism.

PREDELLA The long, lowermost section of an ALTARPIECE.
(*Fig. 11*)

PREFABRICATION Nineteenth-century industrialization resulted
in the gradual displacement of craftsmanship by
manufacture in European and American building.
In the twentieth century, with the manufacture of
many building components in factories for easy
on-site assembly, the problems associated with
labor shortages and reduced public housing after
two world wars were reduced.

PREHISTORIC ART The art of painting on the walls of caves lasted from the beginning of the Old Stone Age to the end of the New Stone Age, around 3000 B.C. The Paleolithic cave paintings at Altamira (Spain) and those at Lascaux (France) have been dated between 40,000 and 10,000 B.C.

PRESBYTERY See SANCTUARY.

PRESERVATION In FINE ARTS and architecture, the prevention of destruction, deterioration, or major alterations of a work of art, a building, or an area that contains architecturally significant buildings. Compare RESTORATION and RENOVATION.

PRIMARY COLORS Red, yellow, and blue; by mixing them, all other colors are produced, but primary colors cannot be made from any combination of colors.

PRIMARY STRUCTURES An alternative term for minimal sculpture. See MINIMAL ART.

PRIMING A layer of white (commonly white lead or zinc combined with linseed oil) applied over a SIZED canvas in preparation for painting. By extension, any material applied to a SUPPORT to prepare it to receive PIGMENT.

"PRIMITIVE ART" Material evidence or objects produced in non-Western and prehistoric cultures. The term's scope is vast, encompassing everything from African tribal costumes and masks to the temple sculpture of South America's PRE-COLUMBIAN civilizations. The term appears in quotation marks here to draw into question traditional interpretations: "primitive" reflects many discredited ethnocentric values about progress and Western cultural superiority, while "art" places these objects in an oversimplified aesthetic relation to

Western art completely outside their own cultural contexts, where their significance is more than merely decorative. See PRIMITIVISM.

PRIMITIVES A term applied both to the artists and their works in Italian painting before ca. 1400 and Netherlandish painting before ca. 1450. Sometimes still used in reference to NAIVE or "OUT-SIDER" ART. See PRIMITIVISM.

PRIMITIVISM Generally refers to Western art that has consciously APPROPRIATED non-Western sources. With a desire to transcend REPRESENTATIONAL traditions, MODERN artists sought expressive and spiritual inspiration from the objects and foreign peoples exhibited in ethnographic museums and world's fairs as a result of 19th-century European colonial campaigns. Gauguin's images of Tahitian women exemplify nostalgic notions about the "noble savage" uncorrupted by capitalist civilization. Picasso and other CUBISTS assimilated the STYLE and FORM of African ritual masks with little attention to their use and meaning in their original contexts.

PRINT An impression or PROOF taken from any block or plate which has been prepared for that purpose.

PROCESS ART Unlike the stable forms of MINIMALIST works, process art emphasizes creation and the evolution of an artwork, as with Carl Andre's steel units that depend on the process of rust for their full meaning. PERFORMANCE ART and BODY ART are kinds of process art. It began in the 1960s and continued into the 1970s.

PRONAOS The front porch of a classical temple, enclosed by the side walls and in front by the COLONNADE. It forms a vestibule to the SANCTUARY. (*Fig. 2*)

PROOF PRINT made for the artist to examine before the STATE is printed, either by the artist or by a printer. See ARTIST'S PROOF.

PROVENANCE Strictly, the history of ownership of a work of art. In general use, it means also the place of its creation.

PSALTER Liturgical book containing the text of the Psalms.

PSYCHOANALYTIC THEORY See FEMINISM, SURREALISM.

PUBLIC ART Most artwork created since the dawn of history has been public art in the sense that it was located in places of public gathering or worship, such as Greek temple sculpture and medieval church FRESCOES. Since the 1960s, artists' appetites for creating works too large to be exhibited in galleries or museums, coupled with government-sponsored initiatives, have resulted in the placement of large, publicly funded sculptures in many parks and plazas, with various degrees of critical and popular success. Public uproar over Richard Serra's SITE-SPECIFIC *Tilted Arc* in Manhattan eventually forced its removal. Other artists created EARTHWORKS, such as Christo's *Running Fence*, which required vast amounts of open space. See MEDIA ART.

PURISM A movement founded in 1918 by Le Corbusier and Amédée Ozenfant to restore and "purify" CUBISM by working on cubist principles without allowing any NON-OBJECTIVE, decorative additions to muddle their purpose. While its influence on painting was minimal, in architecture its resonance was felt strongly through the work of Le Corbusier.

PUTTO (It., small boy; pl., putti) The chubby, usually naked baby common in European art from the

RENAISSANCE through the ROCOCO. May have wings. Adapted by Renaissance artists from depictions of Eros figures in Hellenistic and Roman art, and used mainly as a decorative convention.

PYLON A monumental gateway in the form of a truncated pyramid, typically (as a gateway to Egyptian temples) two such structures connected by a gate. By extension, any monumental architectural mass that surrounds an entranceway.

PYRAMIDAL COMPOSITION A composition based on the outline of a triangle (or pyramid), popular in Italian RENAISSANCE ART and fully explored by Raphael. The focal group is disposed with the largest mass at the base and the smallest mass at the apex, e.g., a Madonna and Child with the Madonna's head forming the apex. Also called triangular composition.

PYROXYLIN Synthetic MEDIUM more commonly known as LACQUER, or by various trade names. It is thinned like lacquer and is practical in both a thick and a thinned consistency.

QUADRATURA Illusionistic painting on a ceiling or wall in which PERSPECTIVE and FORESHORTENING of architectural members, figures, etc., give the impression that the interior is open and limitless. Practiced by Italian BAROQUE specialty painters, known as quadraturisti or quadratisti.

QUARTO A book, measuring not larger than 9 1/2 by 12 1/2 inches, which is composed of sheets folded into four leaves.

QUATREFOIL Decorative motif with four lobes, associated with GOTHIC TRACERY.

QUATTROCENTO (It., four hundred) The 15th century, used especially when referring to Italian art and literature of that century.

QUEEN ANNE STYLE An American architectural style of the late 19th century which exuberantly combined many unlike textures, materials, and forms into an asymmetrical, composite building. Towers, turrets, elaborate chimney pots, BAYS, projecting porches, and verandas are all hallmarks of a Queen Anne structure.

RADIATING CHAPEL A CHAPEL that projects from the AMBULATORY of a ROMANESQUE or GOTHIC church or cathedral. It usually occurs in series, as shown at the top of *Fig. 4.*

RAKU Coarse-grained, low-fired, and soft-glazed POTTERY ware developed by the Japanese for articles used in the tea ceremony. It is notable for its refined rusticity.

RAYONISM A Russian movement, a short-lived offshoot of CUBISM and a parallel to FUTURISM, started in 1913 by Mikhail Larionov and Natalia Goncharova. Their emphasis on rendering parallel and crossed beams of light to suggest the FOURTH DIMENSION was important to the development of SUPREMATISM.

READY-MADES Associated with DADA, especially with Marcel Duchamp, these are randomly selected and mass-produced FOUND OBJECTS, often nonsensically combined and presented as art. For Duchamp, found objects implied the exercise of AESTHETIC taste, whereas ready-mades did not. See ANTI-ART.

REALISM Fidelity to natural appearances without slavish attention to minute details (see NATURALISM). As a movement, it goes back to Courbet and Manet in the 1850s and culminates in IMPRESSIONISM.

REAPPROPRIATION See APPROPRIATION/ REAPPROPRIATION.

RECESSION The appearance or illusion of depth in a picture, achieved by FORESHORTENING and various techniques of PERSPECTIVE, the use of COULISSE, REPOUSSOIR, etc.

RECTILINEAR STYLE See PERPENDICULAR STYLE.

RED-FIGURE VASE PAINTING Technique and style of Greek vase painting developed about 525 B.C. (after BLACK-FIGURE VASE PAINTING) and dominating the art of the 5th century B.C. Black GLAZE is painted around the forms and figures of the reddish-brown clay, with inner details painted in. The finest Greek wares are in the red-figure style.

REDUCING GLASS A lens capable of making large objects appear smaller for purposes of study or transferral to a drawing or canvas. A CLAUDE GLASS is a form of reducing glass. Also called diminishing glass.

REEDING Ornament for architecture and furniture composed of straight, closely spaced, raised, semicircular bands.

REFLECTED COLOR The phenomenon of one COLOR reflected onto another, affecting its hue.

REGENCY STYLE The English counterpart to the DIRECTOIRE and EMPIRE styles of French architecture and DECORATIVE ART. Seen in the late years of the 18th century to about 1830. Greek, Roman, ROCOCO, oriental, GOTHIC, and Egyptian elements and motifs were used in a style that profoundly affected British and American tastes.

REGIONALISM Now understood to be a movement within AMERICAN SCENE PAINTING. Protesting against the spread of European MODERNISM, the regionalists sought an authentic American STYLE by concentrating on realistic depictions of the rural Midwest

and South of the 1930s. The best-known regional-ists were Grant Wood, Thomas Hart Benton, and John Steuart Curry.

REGISTRATION In GRAPHIC ARTS, the alignment of correspond-ing parts, as when separate colors are printed in the same image.

REINFORCED CONCRETE Concrete reinforced with iron or steel bars, used in modern building construction. Also called ferroconcrete.

RELIEF Carving, molding, or stamping in which the DESIGN projects from or is sunk into the surface. The degree of projection varies from shallow (BAS-RELIEF) to deep (ALTO RILIEVO).

RELIEF PROCESS In GRAPHIC ARTS, the method of producing PRINTS in which the parts not to be seen are cut away from the surface. The major relief processes are WOODCUT or woodblock, WOOD ENGRAVING, and LINOLEUM BLOCK.

RELINING (lining) Mounting a painting, with its original can-vas, on a new canvas SUPPORT.

RELIQUARY Receptacle for relics, usually made of precious materials, and sometimes in a form indicating the kind of relic contained, e.g., an arm-shaped reli-quary for a particle of a saint's arm.

RENAISSANCE ART Strictly, art of the period from ca. 1400 to ca. 1520, but sometimes traced back to the time of Giotto, ca. 1300. During the 14th century, Italian art, especially painting, increasingly took account of scientific PERSPECTIVE and moved toward REALISM. During the 15th century, early Renaissance development was spurred by the rediscovery of ancient classical art. Reached its

climax in the first decades of the 16th century with HIGH RENAISSANCE ART.

RENOVATION In architecture, the upgrading of a building by retaining or restoring the major original exterior features while accommodating the interior to contemporary needs. Compare RESTORATION and PRESERVATION.

REPLICA A COPY of a painting or sculpture—made by the artist of the ORIGINAL or someone under the artist's supervision—which is so exact that it is difficult or impossible to know which is the original.

REPOUSSÉ Ornamental metalwork in which the design is hammered into RELIEF from the reverse side. Often incorrectly used to mean EMBOSSING.

REPOUSSOIR A compositional device; an object placed in the foreground near one side to direct the eye to the center of the picture. See COULISSE.

REPRESENTATION Refers to that which is representational. Art historians once limited ICONOGRAPHICAL studies to art, but as a result of POSTMODERN influences, the study and critique of many representations (e.g., visual examples drawn from POPULAR CULTURE, especially the mass media) have become increasingly important. The often mentioned "crisis of representation" in the arts refers to current dilemmas regarding the values and biases always present in visual depictions and yet masking as accurate realities.

REPRESENTATIONAL ART In contrast with NON-OBJECTIVE and ABSTRACT ART, representational art strives to depict figures and objects as they appear to the eye.

REPRODUCTION COPY of an ORIGINAL work of art, usually in another MEDIUM, such as a printed reproduction of a painting. See COMMODIFICATION.

REREDOS An ornamental screen covering the wall behind an ALTAR in a church. Most highly developed in Spanish art.

RESTORATION In FINE ARTS and architecture, the return of a work of art or a building to its original condition, or as close as is technically possible. The term conservation is often preferred to restoration in speaking of such a process in the fine arts. Compare PRESERVATION and RENOVATION.

RETABLE A raised shelf at the back of the ALTAR slab (mensa) (*Fig. 11*) on which are placed the altar CROSS, altar lights, etc. Also, an early medieval type of ALTARPIECE which consists of a single, low, horizontal panel. Later, also refers to the raised, framed part of an altarpiece above the PREDELLA section.

RETARDATAIRE (Fr., behind) In describing a work of art or architecture, it denotes archaicism or a seeming lack of awareness of contemporaneous techniques and/or styles. Compare ARCHAIC, ARCHAISM, ARCHAICISM.

RETINAL PAINTING See OP ART.

RETOUCHING Reworking damaged portions of a painting by repainting.

RETREATING COLOR A cool COLOR, e.g., blue, which suggests distance, or at least does not appear to come to the fore. See ADVANCING COLOR.

REVERSE PAINTING ON GLASS Painting technique in which the image is painted on the back of colorless glass to

be seen from the front. Mostly practiced by FOLK ARTISTS and amateurs.

RHYTON An ancient drinking vessel, usually ceremonial, in the form of an animal's head, a woman, or a mythological creature.

RIB MOLDING or projecting band on a ceiling or VAULT. Usually serves as the principal supporting member of the ceiling, but may be purely decorative. (*Fig. 9*)

RILIEVO SCHIACCIATO (It., flattened relief) An extremely delicate and subtle form of low RELIEF perfected by a few 15th-century Italian sculptors. It achieved advanced atmospheric effects through the skillful modulation of the stone's surface.

RINCEAU Ornament of leafy scrolls.

ROCAILLE (Fr., rockwork: also Fr. for rococo) The curvilinear ornament—with endless variations—based on the mussel shell; it appeared in BAROQUE ART about 1730, signaling the beginning of the ROCOCO style. Also, the shell and stonework typical of rococo garden and grotto decoration.

ROCOCO ART European art of the period from ca. 1730 to ca. 1780 characterized by the use of curvilinear ornament (see ROCAILLE). Considered the final phase of BAROQUE ART, rococo art is aristocratic, displaying a love of elegance in both STYLE and subject matter. The French artists Watteau, Boucher, and Fragonard exemplify this art in painting, while fine examples in architecture are found in Germany and Austria as well as in other parts of Europe.

ROMAN CLASSICISM An American manifestation of English GEORGIAN architecture, favored especially by

Thomas Jefferson and seen ca. 1790 to 1830. A raised first floor, a Roman-style columned PORTICO raised on a podium, and severity of ornament characterize the style.

ROMANESQUE ART Art of the period ca. 1000 to ca. 1150 in the Île-de-France, until the early 13th century elsewhere in Europe. Its chief creations were massive monastic churches built with stone VAULTS reminiscent of Roman architecture.

ROMANTICISM (romantic art) A style prevalent in the first half of the 19th century, particularly in painting, in which imagination played the dominant role. Referring more to a state of mind than to a style, romanticism was a marked reaction against the rationalism associated with NEOCLASSICISM. One of the chief concerns of the romantic artist was the illustration of literary themes, often derived from contemporary romantic writings. Leading romantic artists included Eugène Delacroix, William Turner, and Caspar David Friedrich.

RONDO A circular surface, such as for a painting, mirror, etc. Also, a roundel, or circular inlay, in a piece of furniture. See TONDO.

ROOD The Saxon word for CROSS or crucifix. See ROOD SCREEN.

ROOD SCREEN (Fr., jubé) An architectural screen of openwork separating the CHANCEL from the NAVE of a church. It may be elaborate in design and be surmounted by a ROOD.

ROSE WINDOW Circular window with elaborate radiating TRACERY. Very ornate rose windows with complex ICONOGRAPHIC themes worked in STAINED GLASS are a signal feature of GOTHIC architecture.

ROTUNDA A round building, inside and out, often sur-
mounted by a dome. Also, a large dome-covered
interior area of a building.

ROUGHCAST A granular composition (sand and lime, for
instance) applied to a wall as the first coat in
preparation for FRESCO painting. The ARRICCIO
adheres to the roughcast.

RUBBING See FROTTAGE.

RUBÉNISME Artistic theory in France in the second half of the
17th century and the early 18th century, champi-
oning the primacy of color over line. Rubénistes
opposed the Poussinistes, who favored line.
Adherents of the two sides were named after
Rubens and Poussin, who in their paintings had
emphasized color and line, respectively.

RUSTICATION Masonry (either rough-hewn or smooth with
beveled edges) laid with deep-set joints. Often
used on the ground floor of RENAISSANCE and
BAROQUE buildings.

S

"S" CURVE Applied to standing figures in GOTHIC ART, it is the effect produced when the hip section is thrown either to one side or forward. First appears in French sculpture of the 13th century, and dominates figure drawing for almost 200 years. See CONTRAPPOSTO.

SACRA (SANTA) CONVERSAZIONE A type of representation of the Madonna and Child with saints, developed by 15th-century Italian painters (Domenico Veneziano, Fra Filippo Lippi, and Fra Angelico), in which the persons represented occupy a unified space instead of separate panels and are made to appear related to each other by gesture and attitude.

SACRAMENTARY Liturgical book containing the celebrant's part, including prayers, to be recited at mass.

SALON Annual exhibition of painting and sculpture in France, e.g., the Paris Salon, Salon d'Apollon. Dates from the early 17th century through the 19th century.

SALON DES REFUSÉS The exhibition promoted by Napoleon III in 1863 to show works rejected by the Paris Salon. Because it undermined the prestige of the ACADEMIC ART sanctioned at the official salon, it is often cited as signaling the birth of the AVANT-GARDE and MODERN ART. It showed works by Edouard Manet, Eugène Boudin, Ignace Henri

Fantin-Latour, Camille Pissarro, James McNeill
Whistler, and others.

SANCTUARY Area around the main ALTAR of a church. Also
called the presbytery.

SANGUINE Red chalk, a principal drawing MEDIUM of the OLD
MASTERS.

SARCOPHAGUS Chest-shaped coffin made of stone or made to
be placed in the open. Favored by Romans and
early Christians, who used the sides and lid as
fields for sculptured ornamentation.

SATURATION The degree of brilliance of a hue or tint (see
COLOR), ranging from light and bright to dull and
grayed.

SC., SCULP., SCULPT., SCULPSIT, SCULPEBAT (Lat., sculpsit = has
carved it) On a PRINT, identifies the engraver.
Used like *fecit* (see F., FE., FEC., FECIT) and *incidit*
(see INC., INCID., INCIDIT, INCISOR).

SCALING The flaking-off of oil paint from the GROUND, caused
by careless PRIMING or mixing of PIGMENT or var-
nish, rolling or folding the canvas, or moisture
attacking the back.

SCARAB A conventionalized Egyptian representation of a flat-
bellied beetle, often of stone or FAIENCE and with
hieroglyphs incised on the underside. Used as a
talisman, an ornament, and, when interred with a
mummy, as a symbol of resurrection.

SCHOOL A group of artists working under the same influence
—whether a single master, a local style, or a
regional style—whose work shows a general styl-
istic similarity, e.g., Rubens school, Barbizon
school, Tuscan school. Compare "CIRCLE OF," "FOL-
LOWER OF," "MANNER OF," WORKSHOP.

SCUMBLE To apply a thin layer of opaque COLOR over an underlayer so that, seen together, the layers produce a softened effect.

SECONDARY COLORS Orange, green, and violet: the COLORS formed by the mixture of any two PRIMARY COLORS in equal or equivalent parts.

SECTION The drawing of a building showing it as if sliced through vertically—either lengthwise (longitudinal section) or through its narrow side (transverse section). Compare PLAN, ELEVATION, and ISOMETRIC PROJECTION.

SEICENTO (It., six hundred) The 17th century, used especially when referring to Italian art and literature of that century.

SEMI-DOME A DOME that is significantly less than a full hemisphere in height.

SEMIOTICS An argument for the construction of meaning through structures of symbols that began with early-20th-century linguistics. In it the "signifier" (a written or spoken word) and the "signified" (the actual object or concept referred to) together form a "sign." It became useful for examining other cultural products as codes, including art. Magritte's *The Uses of Words I* takes a semiotic approach to art-making. By painting the words *Ceci n'est pas une pipe* (This is not a pipe) under the image of a pipe, he questioned pictorial and linguistic REPRESENTATION. It is not actually a pipe, merely its image. The broader impact of semiotics has been in POSTMODERN art and criticism in studies of the power of cultural signs that are examined, reexamined, and DECONSTRUCTED.

SERDAB In Egyptian tombs, the chamber that houses the funerary statue.

SERIAL ART (SERIAL IMAGERY) The repetition, with slight varia-
tions, of an image in the same work of art,
whether a single canvas or related modules of a
sculptured work; named in the late 1960s. Andy
Warhol and Donald Judd have both worked in the
serial image mode. It displays some traits of SYS-
TEMIC PAINTING, although it is a distinct movement.

SERIGRAPHY See SILK SCREEN.

SFREGAZZI Glazed shadows over flesh colors, applied with
the fingers.

SFUMATO (It., evaporated) The soft gradation of light tones
into dark ones, such that all sharply defined con-
tours are eliminated. About light and shade in
painting, Leonardo da Vinci wrote that they
should blend imperceptibly, "without lines or bor-
ders, in the manner of smoke." Compare
CHIAROSCURO.

SGRAFFITO (It., scratched; pl., sgraffiti) A technique of deco-
rating STUCCOED surfaces, in which a layer of col-
ored plaster is laid over a dry underlayer and
then incised with designs while still damp—mak-
ing use of the contrasting color of the underlayer.
Also, a drawing or words hastily scratched or
written on a wall. See GRAFFITI ART.

SHADE The dark degree of a hue (see COLOR). Also, the
degree of brilliance or luminosity of a color. Also,
those areas of a picture representing the absence
of light—"light and shade."

SHAPED CANVAS A painting in three-dimensional form in
which the canvas is stretched over a framework to
produce an unconventional shape.

SHARP-FOCUS REALISM See MAGIC REALISM.

SHEFFIELD PLATE Objects made during the second half of the 18th and first half of the 19th centuries in England using a thin sheet of silver fused to a sheet of copper.

SICCATIVE A preparation added to PIGMENTS, oils, or varnishes to hasten their drying.

SIDE AISLE Narrow corridor between rows of COLUMNS, or columns and wall, on either side of the NAVE in a BASILICA. (*Fig. 3*)

SIGNIFICANT FORM Critic Clive Bell's term for the AESTHETIC element in a work of art, irrespective of its CONTENT. See MODERNISM, FORMALISM.

SILHOUETTE A profile likeness of a person or scene cut from black paper and usually mounted against a white background. Named for a French amateur practitioner of the art, Etienne de Silhouette, Louis XV's finance minister.

SILK SCREEN A stencil process of color reproduction, often used commercially to reproduce posters, etc. The design is divided according to color areas. For each color, a stencil is prepared on silk stretched over a frame. Paint is then squeezed through the respective screens. Andy Warhol used this technique extensively. Also called serigraphy.

SILVER POINT A method of drawing in which great delicacy is achieved by using a specially coated and often tinted paper and a silver-tipped drawing instrument. Extensively practiced in the 15th and early 16th centuries.

SILVER PRINT See GELATIN PRINT.

SIMULTANEOUS REPRESENTATION The representation of an object, person, or structure in such a way that its

most essential features are all seen in one view without regard to PERSPECTIVE or a single point of view. Seen in Egyptian art and some CUBIST phases.

SINKING IN The dull, MATTE quality of an oil painting, or parts of it, that results when the PIGMENT is absorbed by the GROUND.

SINOPIA (pl., sinopie) An underdrawing in reddish-brown PIGMENT made by a painter preparatory to executing a FRESCO. New RESTORATION techniques have facilitated the recovery of numerous sinopie, many of which are quite different from the final frescoes. Also, an ochre color pigment.

SITE-SPECIFIC Artwork created, designed, or selected for a specific indoor or outdoor site. It may take shape as publicly displayed monumental sculpture commissioned by either city arts agencies or private corporations, or as EARTH ART, often located away from urban centers. Beverly Pepper's *Fallen Sky*, located in Barcelona, merges park with sculpture. This undulating earthen mound covered in multicolored tiles is a recent tribute to Gaudí and the city's ART NOUVEAU heritage. See also INSTALLATION, PUBLIC ART.

SITUATIONISM The Situationist International was founded in 1957 with the merging of three European AVANT-GARDE literary and artistic groups. With roots in DADA's assault on bourgeois sensibilities, the situationist movement emerged in Western Europe primarily in the 1960s. The situationists were highly politicized and theoretical, seeking, in their writings and art, to bring back meaningful social interactions to members of a depoliticized consumer society. Some artworks, such as paintings larger than buildings, blurred the boundaries between art forms. Others were altered reproduc-

tions of famous works, prefacing the REAPPROPRI-ATED works of the 1980s and 1990s. The movement's influence provided a theoretical base for students involved in the French general strike of 1968.

SIZE A glutinous substance used for filling the pores of canvas, paper, etc., and also as an adhesive GROUND for gold leaf.

SKETCH A drawing, painting, or model made as a rough draft of the COMPOSITION, preliminary to executing a work of art. Alternatively called modello, pensiero, sprezzatura, esquisse.

SLIP Clay diluted to a creamy consistency for coating or decorating POTTERY.

SOCIAL REALISM A trend in 20th-century art before 1950. Often political in nature, social realism is distinctive for its REALISTIC depiction of the ills of society. The influence of Mexican MURALISTS Diego Rivera, José Clemente Orozco, and David Alfaro Siqueiros was felt by North American social realist and WPA artists. Some North Americans emerged from the ASHCAN SCHOOL, while others, like Ben Shahn, evolved separately.

SOCIALIST REALISM By 1934 this official Soviet style had resulted in staged idealizations of the working class. Derived from FIGURATIVE and NARRATIVE tendencies, these heavy-handed artworks toed the Communist party line and were meant to be accessible to all viewers. In architecture, anti-MODERNISM resulted in a return to heavy classical motifs sometimes known as "Stalinist gothic." (Not to be confused with SOCIAL REALISM.) See FASCIST AESTHETIC.

SOFT PASTE "Frit" or "artificial" PORCELAIN, compounded of some form of white clay mixed with a glassy substance. Made in imitation of HARD PASTE.

SOFT SCULPTURE Sculpture made of pliable and sometimes impermanent materials, such as latex, vinyl, feathers, rope and string, hair, etc. Seen since the early 1960s, soft sculpture defies the tradition of hard and permanent material as the only suitable medium for sculpture. Artists from various movements, including ARTE POVERA, POP ART, and SURREALISM, have experimented with soft sculpture.

SOFT STYLE The German version of INTERNATIONAL STYLE seen from ca. 1380 to ca. 1430 and characterized by extremely soft, curvilinear, drapery folds which contrast with the sharply angular drapery of the style that followed.

SOPRA PORTE Paintings, usually landscapes, designed to fit spaces above doorways in BAROQUE and ROCOCO architecture.

SOTTO IN SÙ (It., from below upward) Describing an extreme form of ILLUSIONISM, practiced especially in late BAROQUE ceiling painting, in which figures and architecture are so FORESHORTENED that they appear to float above the spectator.

SPANDREL Triangular area between the EXTRADOS of an ARCH and the rectangular frame enclosing the arch, or the surface between two arches in an ARCADE. (*Figs. 6, 10*)

SPECTRUM PALETTE The restricted PALETTE first used by the French IMPRESSIONISTS, consisting of the colors of the spectrum (red, orange, yellow, green, blue, indigo, and violet) plus white.

SPREZZATURA. See SKETCH.

SQUARING (SQUARING UP) A way of transferring a small sketch to a larger surface by dividing both into the same number of squares, and then copying the DESIGN in each square of the smaller drawing onto the corresponding square of the larger surface.

STABILE A stationary ABSTRACT sculpture without moving parts. Compare MOBILE.

STAFFAGE Animal or human figures in architecture or landscape painting that are included for interest or to help establish scale and/or PERSPECTIVE.

STAINED GLASS Glass given translucent color by staining with metallic oxides and joined with lead strips to form a design or scene.

STAND OIL Oil (linseed oil) boiled with the exclusion of air. Thinned and used in paint, it produces a smooth, enamel-like surface.

STATE In GRAPHIC ARTS, all IMPRESSIONS pulled from an unaltered printing surface. Artists may make changes in the block, plate, etc., thus producing several states of the same print.

STAVE CHURCH Timber-framed and timber-walled Scandinavian church erected after 1000 A.D.

STELE An upright slab used as a gravestone, especially by the ancient Greeks. Frequently sculpted or painted.

STENCIL A simple GRAPHIC ARTS process in which the DESIGN is cut into a thin, flexible material (such as cardboard) and the color is brushed through the openings onto paper, fabric, wall surfaces, etc. SILK SCREEN is a stencil process. See POCHOIR.

STEREOBATE A masonry substructure above ground level on which a classical temple stands. Its topmost level is the STYLOBATE. (*Figs. 1, 2*)

STERLING SILVER See COIN SILVER.

STILL LIFE (Fr., nature morte) A painting, drawing, or MOSAIC of a group of inanimate objects, i.e., dead or at least motionless objects, such as fruit, flowers, dead fish or game, and common household objects. Still lifes were typical of Greek and Roman mosaics, but they did not reemerge until the 16th century, when they became popular subjects especially in Dutch, Flemish, Spanish, and Neapolitan painting. See VANITAS.

STIPPLE PRINT A PRINT created by building up the DESIGN from minute dots or flicks. Stipple is used with both ETCHING and ENGRAVING processes, with the intent to resemble CRAYON.

STIPPLING A method of WATERCOLOR painting popular in the 19th century, in which the DESIGN is laid down in small dots or dabs of color.

STOA A roofed PORTICO of Greek origin. Usually long and facing on a public meeting place. Walled at the back and with a COLONNADE in front.

STONEWARE Extremely hard, nonporous CERAMIC WARE made of thick, impure clay fired at a relatively high temperature (ca. 1250° C). It is most often covered with a GLAZE.

STRAPWORK A form of ornament common in the late 16th century, made of interlaced and intertwined bands.

STREET WORKS Planned, patterned demonstrations in city streets, usually protesting or advocating some-

thing. Usually involve some action, such as planting a tree or carrying posters in a procession and later affixing them to a wall. Similar to street theater but without a dramatic plot structure; a form of PERFORMANCE ART.

STRETCHER Wooden frame on which the canvas SUPPORT for a painting is stretched. Can be further tightened by means of wedges in the corners.

STRIATION Pattern of narrow stripes or closely parallel lines, such as those used to render drapery in BYZANTINE and ROMANESQUE art.

STRUCTURALISM Seen as a form of CONSTRUCTIVISM, it is manifest as low-RELIEF sculpture that interprets nature in the tradition of Cézanne by the application of simple geometric forms to a flat surface. Named by American artist Charles Biederman, it has a strong following in Holland and Canada.

STUCCO Slow-setting plaster used on walls and ceilings, for RELIEF decoration or as a GROUND for FRESCO.

"STUDIO OF" See WORKSHOP.

STUDY A carefully worked out detail in drawing, painting, or BOZZETTO of a proposed work of art. In its thoroughness, it differs from a preparatory sketch.

STYLE The characteristic manner and appearance of the works of an individual artist, SCHOOL, or period. Stylistic elements comprise qualities resulting from both FORM and CONTENT. Artistic styles emerge from individual and collective interpretations in social, political, and economic contexts.

"STYLE OF" See "MANNER OF."

STYLOBATE In a classical temple, the pavement or platform on which the COLUMNS stand; the uppermost level of the STEREOBATE. (*Figs. 1, 2*)

SUITE A series of paintings, drawings, or PRINTS linked by a common theme, occurring most often in LITERARY ART, e.g., William Hogarth's *The Rake's Progress*.

SUMERIAN ART See ANCIENT NEAR EASTERN ART.

SUNDAY PAINTER An amateur artist who paints solely for pleasure.

SUPERREALISM A term coined by Sir Herbert Read to replace the term SURREALISM, but rarely used today.

SUPPORT The untreated surface to which, after PRIMING, paint is applied. A support may be a wood panel, canvas, cardboard, a wall, copper plate, etc.

SUPREMATISM. An outgrowth of RAYONISM, but more immediately of ANALYTIC CUBISM, suprematism was a Russian movement founded in 1915 by Kazimir Malevich, who used the circle, rectangle, triangle, and cross as the basis of a purely ABSTRACT style and as a vehicle for his spiritual ideas. Suprematism proved highly significant in the development of CONSTRUCTIVISM, despite the latter's more utilitarian outlook.

SURREALISM Originally a literary movement, officially inaugurated in 1924, it incorporated stylistic and theoretical aspects of CUBISM and DADA. Seeking to reveal the reality behind appearances, especially in a psychological sense, surrealism drew heavily on Freudian theories about the unconscious, dreams, irrationality, sexuality, and fantasy. Hence, the use of dream imagery, AUTOMATISM, and symbolism. Some major figures: Joan Miró, Salvador Dalí, Yves Tanguy, Max Ernst.

SYMBOLIST MOVEMENT A literary movement in France (Stéphane Mallarmé, Charles Baudelaire, Paul Verlaine) which got underway about 1885 in reaction to REALISM and IMPRESSIONISM. In painting, Gustave Moreau, Pierre Puvis de Chavannes, Odilon Redon, and Gustav Klimt produced lyrical dream fantasies, combining mystical elements with an interest in the erotic and decadent.

SYNCHROMISM Originating in Paris in 1912 with the Americans Stanton MacDonald-Wright and Morgan Russell, this American version of ORPHISM premiered at the ARMORY SHOW in 1913.

SYNTHETIC CUBISM Often referred to as the "second phase of cubism," it lasted from 1912 to 1914. In contrast to ANALYTIC CUBISM, synthetic cubism allowed for a reemergence of tactile qualities and decorative elements. Color and handling became important once again, as did the inclusion of STENCILED lettering and COLLAGE elements.

SYNTHETISM A POST-IMPRESSIONIST direction associated with Paul Gauguin, Emile Bernard, and Maurice Denis, which reduced FORMS to essentials and applied colors as flat, nonshaded fields bounded by strong contour lines.

SYSTEMIC PAINTING Described as a branch of MINIMAL ART and sometimes expanded to incorporate COLOR-FIELD PAINTING, it is a special form of ABSTRACT painting based on an organization—or system—of images, e.g., a painting which is a pure, single field of color, or a series of such paintings; or a painting based on the repetition of a single visual motif, such as a circle, chevron, etc. The term describes certain works by Kenneth Noland and Frank Stella. Closely related to, but not identical with, SERIAL ART.

TACHISME (Fr., spot, blot, stain) The European counterpart to ACTION PAINTING, seen in the decade between 1950 and 1960 and practiced by artists such as Pierre Soulages, Georges Mathieu, and Hans Hartung.

TACTILE VALUES Texture. In painting, the illusion of tangibility — that which stimulates the imagination to sense in a physical way the PLASTIC qualities of an object represented: its weight, mass, distance, texture, motion or stability, warmth or coolness.

TALBOTYPE See CALOTYPE.

TATLINISM See CONSTRUCTIVISM.

TEMPERA A painting material in which the PIGMENT (dissolved in water) is mixed, or tempered, with an albuminous, gelatinous, or colloidal MEDIUM. Egg yolk is the most common tempera VEHICLE.

TEMPERING In painting, the mixing of COLORS.

TENEBRISTS Michelangelo da Caravaggio and the 17th-century painters influenced by him who painted interior scenes, often lighted by candles or torches, having sharp contrasts of light and SHADE. Georges de La Tour (French) and José de Ribera (Spaniard in Naples) are considered tenebrists. The words tenebrist and tenebrism were coined by later critics. See CHIAROSCURO.

TERRA-COTTA A hard, fired but unglazed clay ranging in color from pink to purple-red, but usually a brownish-red. Used since ancient times for sculpture and POTTERY, later for architectural decoration.

TERTIARY COLORS COLORS produced by the mixture of two SECONDARY COLORS.

TESSERA (pl., tesserae) Small cube of glass, marble, stone, etc., used in the execution of MOSAIC.

THOLOS A circular building of Greek date and style. Also, a beehive-shaped underground tomb of late Helladic origin which was approached by a gateway cut into the side of the hill in which the tomb was dug, e.g., the so-called Treasury of Atreus at Mycenae.

THROWING In CERAMICS, the term used to describe the process of building up a pot, vase, dish, etc., on a potter's wheel. Hence, "to throw a pot."

TINSEL PAINTING A picture painted on glass and backed by crinkled tinfoil. A popular 19th-century parlor art. Also called crystal painting.

TINT See COLOR.

TINTYPE A photographic process in which a direct positive image is produced on a small, lightweight iron plate by a variation of the COLLODION WET PLATE process. Popular until the late 19th century, especially with itinerant portrait photographers, who made and sold them cheaply. Also called ferrotype.

TOLE Items of tinware painted with decorative designs. Also called toleware, it was much practiced by amateurs and artisans in the 18th and 19th centuries.

TONDO A circular painting or sculptured medallion. See RONDO.

TONING Tinting the monochrome UNDERPAINTING of oil paintings with GLAZE and SCUMBLE.

TOOTH The roughness or grain of the SUPPORT.

TRACERY Openwork pattern of intersecting MOLDINGS, most typically appearing in GOTHIC windows. See BLIND TRACERY, PLATE TRACERY.

TRANSEPT The transverse arm of a cruciform BASILICA or church. Its intersection with the main axis of the church is the CROSSING. Occasionally double transepts and transepts at the front are found. (*Figs. 3, 4*)

TRANSITIONAL Describing stylistic phases in which features of both a passing and a coming STYLE are evident. Applied usually to architecture. Also (cap.), the change of style from Norman to EARLY ENGLISH in English architecture.

TRANSLUCID PAINTING Painting with thinned oil color over a metal foil (leaf) surface. Also called golden painting.

TRECENTO (It., three hundred) The 14th century, used especially when referring to Italian art and literature of that century.

TREFOIL Decorative design with three lobes, often found in GOTHIC TRACERY.

TRIAL PROOF See PROOF.

TRIANGULAR COMPOSITION See PYRAMIDAL COMPOSITION.

TRIFORIUM A shallow, arcaded passage in the wall of the NAVE between the main ARCADE below and the CLERESTORY above. (*Fig. 9*)

TRIGLYPH A slightly projecting block having three vertical grooves. Triglyphs alternate with METOPES on the FRIEZE of the Greek Doric ENTABLATURE. (*Fig. 1*)

TRIPTYCH A painted or carved work in three parts or panels arranged side by side. The flanking panels are usually half the width of the central panel and hinged so that they can be closed over it. A common form of ALTARPIECE. See DIPTYCH, POLYPTYCH. (*Fig. 11*)

TRIUMPHAL ARCH Originating in Rome by the 2nd century B.C., these freestanding monumental gateways were erected to commemorate victorious generals. Sometimes serving as city gates, these ARCHES were often merely decorative and richly adorned with sculptural elements. The two main types include one with a single archway and another flanked with smaller arches to the sides. The triumphal arch form was popularized anew during the Italian RENAISSANCE.

TROIS CRAYONS, À (Fr., in three chalk crayons) Describing a drawing on toned paper in chalk CRAYONS of black, red, and white.

TROMPE L'OEIL (Fr., deceives the eye) Painting that, through precise NATURALISM, the use of SHADE, PERSPECTIVE, or all of these, creates the illusion of being that which is depicted. Most often applied to small details, such as drops of dew on flower petals.

TRUCAGE The FAKING or forgery of painting. See TRUQUEUR.

TRUMEAU The stone center post supporting the TYMPANUM of a doorway. In medieval church architecture it is often decorated with sculpture. (*Fig. 10*)

TRUQUEUR One who practices TRUCAGE; a forger.

TUNNEL VAULT See BARREL VAULT.

TYMPANUM The recessed face of a PEDIMENT or surface above an arched doorway. Often decorated with RELIEF sculpture or painting in ROMANESQUE and GOTHIC buildings. (*Fig. 10*)

TYPEWRITER ART See LETTRISM.

U

UKIYO-E (Jap., pictures of the floating world) WOODBLOCK PRINTS, both MONOCHROME and colored, made as popular ephemera in Japan from the mid-17th century onward. The GENRES of subjects include theater stars, courtesans, caricatures, and, eventually, Hokusai's great Fuji landscape series (1823).

UNDERPAINTING The first painting of a picture, in MONOCHROME, which lays out the general COMPOSITION. Used by some masters for effects in the finished painting. Also called dead coloring and abbozzo.

VALUE See COLOR.

VANISHING POINT In PERSPECTIVE, the point, or points, on the HORIZON LINE at which receding parallel lines meet and seem to disappear. (*Fig. 12*)

VANITAS A type of STILL LIFE in which the objects depicted are reminders of the transience of temporal life. Developed in the 17th century, vanitas employed motifs such as the hourglass, skull, mirror, scales, dying or decaying plant life, and books.

VAULT, VAULTING An arched ceiling or roof constructed of masonry. Simplest is a BARREL VAULT or tunnel vault, which is semicircular in section. Two intersecting barrel vaults of equal size form a GROIN VAULT. Rib vaulting employs reinforced RIBS at the intersections. (*Figs. 7, 8*)

VEDUTA Representation of a town or city which is faithful enough to identify the location. A veduta ideata is an imaginary view. Painters of vedute are called vedutisti. See CAPRICCIO.

VEHICLE Material that binds and carries PIGMENTS in suspension, most commonly gum and water, water and egg yolk, or oil. Compare MEDIUM.

VELLUM Fine grade of parchment made from the skins of calves, lambs, or kids. Used for MANUSCRIPTS and bookbinding.

VERANDA, VERANDAH A roofed but open porch-like construction supported by light upright members.

VERNACULAR ARCHITECTURE Buildings made from local materials to suit localized needs, and designed with minimal reference to prevailing STYLES or trends.

VICTORIAN GOTHIC See GOTHIC REVIVAL.

VIDEO ART Images recorded on videotape to be viewed on television screens. Video technology has provided artists with a new medium for vastly diverse methods of art production. FLUXUS artist Nam June Paik was the first to explore video art, in 1965. Bill Viola, Adrian Piper, and David Wojnarowicz are among many others who have exploited its possibilities. As with photography, video production often brings to the fore the question of veracity in REPRESENTATION.

VIGNETTE An ornament of leaves and tendrils; the flourishes around a capital letter in a MANUSCRIPT; a small decoration or embellishment found in beginning or ending sections of a book or manuscript; a small picture or illustration not enclosed by a definite border but shading off into the surrounding page.

VISIGOTHIC ART The Visigoths were the most Romanized of the Germanic invaders, and thus their cultural legacy (mostly south of the Pyrenees) includes the continuation of late Roman-Christian architectural styles (5th century–711), with one notable addition: the horseshoe-shaped ARCH, adopted by the Arabs after the invasions of 711. The Visigoths

excelled in metalwork and jewelry using gold, crystal, and precious stones.

VOLUTE A spiral, scroll-like ornament. It is the dominating form of the Greek Ionic CAPITAL. (*Fig. 1*)

VORTICISM An English movement, founded by Wyndham Lewis in 1912 and named by Ezra Pound, which reacted against CUBISM and FUTURISM (while owing much of its outlook and style to them). The compositions were ABSTRACT geometric forms organized in arcs around a focal point (vortex). The chief aim seems to have been to make the British aware of advanced movements in modern art on the Continent and elsewhere.

VOUSSOIR One of the wedge-shaped stones in an ARCH. (*Figs. 6, 7*)

W

WASH A thin, transparent layer of WATERCOLOR or ink, usually applied in broad areas. When used in several monochrome layers (usually sepia) in a pen drawing, it is called pen-and-wash.

WATERCOLOR PIGMENT pulverized with a water-soluble binder, such as gum arabic, and dissolved in a water VEHICLE. A transparent technique, in which the paper furnishes the highlights. Compare GOUACHE.

WESTWORK The west part of a CAROLINGIAN or OTTONIAN church, designed to be large enough to accommodate a VAULTED royal chamber in the second story.

WET COLLODION PROCESS, WET PLATE See COLLODION WET PLATE.

WHITE LINE ENGRAVING ENGRAVING in which the design is carved into the surface, not left raised from it, and which consequently appears as a white design on a black field. A RENAISSANCE invention, but a specialty of the 19th-century wood engraver Thomas Bewick.

WIENER WERKSTÄTTEN (Ger., Vienna workshops) An organization of designers and craftsmen established in Vienna in 1903 which espoused the aesthetic principles of the ARTS AND CRAFTS MOVEMENT, but expressed them in a distinctive style akin to ART NOUVEAU.

WOODBLOCK PRINT A variant term for a WOODCUT, used especially for Japanese PRINTS in that technique.

WOODCUT PRINT made from a woodblock cut with the grain on which the parts not cut away form the design. A RELIEF PROCESS, also called WOODBLOCK PRINT.

WOOD ENGRAVING Print taken from the end surface of a hardwood block in which the design is (usually) incised into the surface to produce a WHITE LINE ENGRAVING.

WORKSHOP Refers to those artworks produced primarily by assistants from drawings or CARTOONS by a major artist, generally under his or her supervision. Rubens, for example, would complete the final work, after leaving most of the preliminary details to his workshop. The degree of his intervention was reflected in the cost of the work. Compare "CIRCLE OF," "FOLLOWER OF," "MANNER OF."

WPA: WORKS PROGRESS ADMINISTRATION (later renamed Work Projects Administration) This federal agency (1935–1943) established by the U.S. government provided depression-era relief to the unemployed by commissioning public works. More than 5,000 artists produced works ranging from monumental MURALS (Willem de Kooning) to documentary photographs (Dorothea Lange, Walker Evans).

WRAPPING See EMPAQUETAGE.

YELLOWING Discoloration of an oil painting, the chief causes of which are the excessive use of oil as a VEHICLE, improper SICCATIVE, PIGMENT, or GLAZE, and dampness or darkness.

Z

ZEITGEIST (Ger., spirit of the time) In art terms, refers to certain elements characterizing the mood, thinking, and resulting art production of a period or moment.

ZIGGURAT (Akkadian, ziqqurratu = mountaintop or height). A temple built in the form of a rectangular based pyramid and made of mud brick tapering in stages toward the top. The ziggurat originated with the Sumerians; the Assyrians and Babylonians later followed their example. Well-known ziggurats include those of Ur and Babylon, located in what is now southern Iraq.

ZOOMORPHIC ORNAMENT Ornament based on animal forms.

Bibliography

REFERENCE WORKS: BIBLIOGRAPHIES AND GUIDES

Art Index . 34 vol. Bronx, N.Y., H. W. Wilson, 1935–1990.

Chiarmonte, Paula. *Women Artists in the United States: A Selective Bibliography and Resource Guide on the Fine and Decorative Arts, 1750–1986*. Boston, G. K. Hall, 1990.

Ehresmann, Donald L. *Fine Arts: A Bibliographic Guide to Basic Reference Works, Histories and Handbooks*. 2nd ed. Littleton, Colo., Libraries Unlimited, 1979.

Igoe, Lynn Moody, and James Igoe. *Two Hundred and Fifty Years of Afro-American Art: An Annotated Bibliography*. New York, R. R. Bowker, 1981.

Muehsam, Gerd. *Guide to Basic Information Sources in the Visual Arts*. Guilford, Conn., J. Norton, 1977.

Museum of Modern Art. *Annual Bibliography of Modern Art*. New York, Museum of Modern Art, 1986– .

New York Public Library. *Bibliographic Guide to Art and Architecture*. Boston, G. K. Hall, 1987–1989.

Prosyniuk, Joann, ed. *Modern Arts Criticism: A Bibliographical and Critical Guide*. New York, Gale Research, Inc., 1991.

The Britannica Encyclopedia of American Art. Chicago, Britannica Encyclopaedia Educational Corp., 1973 (distributed by Simon and Schuster, New York).

Chilvers, Ian, and Harold Osborne, eds. *The Oxford Dictionary of Art.* Oxford and New York, Oxford University Press, 1988.

Encyclopedia of World Art. 15 vols. New York, McGraw-Hill, 1959–1968.

Fleming, John, Hugh Honour, and Nikolaus Pevsner. *The Penguin Dictionary of Architecture.* 4th ed. New York, Viking Penguin, 1991.

Harris, Cyril M., ed. *Dictionary of Architecture and Construction.* New York, McGraw-Hill, 1975.

Hatje, Gerd, ed. *Encyclopedia of Modern Architecture.* London, Thames and Hudson, 1963.

International Center of Photography Encyclopedia of Photography. New York, Pound Press, Crown, 1984.

Mayer, Ralph. *A Dictionary of Art Terms and Techniques.* New York, Harper Collins, 1981.

McGraw-Hill Dictionary of Art. 5 vols. New York, McGraw-Hill, 1969.

Murray, Peter, and Linda Murray. *A Dictionary of Art and Artists.* 6th rev. ed. New York, Viking Penguin, 1991.

Osborne, Harold, ed. *The Oxford Companion to Art.* New York, Oxford University Press, 1970.

————. *The Oxford Companion to the Decorative Arts.* New York, Oxford University Press, 1975.

Petteys, Chris. *Dictionary of Women Artists: An International Dictionary of Women Artists Born Before 1900.* Boston, G. K. Hall, 1985.

Phaidon Encyclopedia of Art and Artists. Oxford, Phaidon; New York, Dutton, 1978.

Pierce, James S. *From Abacus to Zeus. A Handbook of Art History.* 2nd ed. Englewood Cliffs, N. J., Prentice-Hall, 1977.

Praeger Encyclopedia of Art. 5 vols. New York, Praeger, 1971.

Read, Herbert, and Nikos Stangos. *Thames and Hudson Dictionary of Art and Artists.* New York, Thames and Hudson, 1985.

Savage, George. *Dictionary of Antiques.* New York, Mayflower, 1978.

————. *Dictionary of Nineteenth Century Antiques and Later Objets d'Art.* New York, Putnam, 1978.

White, Norval. *The Architecture Book.* New York, Knopf, 1976.

REFERENCE WORKS: ICONOGRAPHY

Bernen, Satia, and Robert Bernen. *Myth and Religion in European Painting 1270–1700.* New York, Braziller, 1973.

Daniel, Howard. *Encyclopedia of Themes and Subjects in Painting.* New York, Abrams, 1971.

Ferguson, George. *Signs and Symbols in Christian Art.* Oxford and New York, Oxford University Press, 1966.

Hall, James. *Dictionary of Subjects and Symbols in Art.* Rev. ed. New York, Harper & Row, 1979.

Schiller, Gertrud. *Iconography of Christian Art.* 2 vols. Greenwich, Conn., New York Graphic Society, 1969, 1972.

Sill, Gertrude G. *A Handbook of Subjects and Symbols in Christian Art.* New York, Macmillan, 1975.

General Histories of Art and Architecture

Gardner, Helen. *Art Through the Ages.* 6th ed. New York, Harcourt Brace Jovanovich, 1975.

Janson, Horst W. *History of Art: A Survey of the Major Visual Arts from the Dawn of History to the Present.* 4th rev. ed. New York, Abrams, 1990.

Kostof, Spiro. *A History of Architecture: Settings and Rituals.* New York, Oxford University Press, 1985.

Scully, Vincent. *Architecture: The Natural and the Manmade.* New York, St. Martin's Press, 1991.

"Primitive" and Prehistoric Art

Adam, Leonhard. *Primitive Art.* New York, Barnes and Noble, 1963.

Clifford, James. *The Predicament of Culture: Twentieth-Century Ethnography, Literature, and Art.* Cambridge, Mass., Harvard University Press, 1988.

Fraser, Douglas. *Primitive Art*. New York, Doubleday, 1962.

Grand, Paule M. *Prehistoric Art: Paleolithic Painting and Sculpture*. Greenwich, Conn., New York Graphic Society, 1967.

Leroi-Gourhan, André. *Treasures of Prehistoric Art*. New York, Abrams, 1967.

Leuzinger, Elsy. *The Art of Black Africa*. Greenwich, Conn., New York Graphic Society, 1972.

Pericot-Garcia, Luis, John Galloway, and Andreas Lommel. *Prehistoric and Primitive Art*. New York, Abrams, 1968.

Sanders, Nancy K. *Prehistoric Art in Europe*. New York, Viking Penguin, 1985.

Torgovnick, Marianna. *Gone Primitive: Savage Intellects, Modern Lives*. Chicago, University of Chicago Press, 1990.

Willett, Frank. *African Art*. New York, Praeger, 1971.

Wingert, Paul S. *Primitive Art: Its Traditions and Styles*. New York, Oxford University Press, 1962.

ANCIENT ART AND ARCHITECTURE

Becatti, Giovanni. *The Art of Ancient Greece and Rome*. New York, Abrams, 1967.

Boardman, John. *Greek Art*. London and New York, Thames and Hudson, 1985.

Boardman, John, José Dörig, and Werner Fuchs. *The Art and Architecture of Ancient Greece*. New York, Abrams, 1967.

Brilliant, Richard. *Arts of the Ancient Greeks.* New York, McGraw-Hill, 1973.

————. *Roman Art from the Republic to Constantine.* London, Phaidon, 1974.

Frankfort, Henri. *The Art of the Ancient Orient.* 4th ed. Harmondsworth, England, and Baltimore, Penguin, 1970.

Hafner, German. *Art of Rome, Etruria and Magna Graecia.* New York, Abrams, 1969.

Hanfmann, George M. A. *Roman Art: A Modern Survey of the Art of Ancient Rome.* New York, Norton, 1975.

Heintze, Helga von. *Roman Art.* New York, Universe, 1971.

Lange, Kurt. *Egypt.* 4th ed. New York, Phaidon, 1968.

Lloyd, Seton. *The Art of the Ancient Near East.* New York, Praeger, 1961.

Mansuelli, Guido A. *The Art of Etruria and Early Rome.* New York, Crown, 1965.

Marinatos, Spyridon. *Crete and Mycenae.* New York, Abrams, 1960.

Matt, Leonard von. *The Art of the Etruscans.* New York, Abrams, 1970.

Matz, Friedrich. *The Art of Crete and Early Greece.* New York, Crown, 1962.

Michalowski, Kazimierz. *The Art of Ancient Egypt.* New York, Abrams, 1969.

Richter, Gisela M. A. *A Handbook of Greek Art.* 9th ed. New York, Da Capo, 1987.

Schuchhardt, Walter-Herwig. *Greek Art.* New York, Universe, 1990.

Smith, William S. *Art and Architecture of Ancient Egypt.* London, Penguin, 1958.

Strong, Donald. *Roman Art.* Harmondsworth, England, and Baltimore, Penguin, 1976.

Summerson, John. *The Classical Language of Architecture.* Cambridge, Mass., MIT Press, 1963.

Toynbee, Jocelyn M. C. *The Art of the Romans.* New York, Praeger, 1965.

Westendorf, Wolfhart. *Painting, Sculpture and Architecture of Ancient Egypt.* New York, Abrams, 1969.

Wolf, Walter. *The Origins of Western Art: Egypt, Mesopotamia, the Aegean.* New York, Universe, 1971.

MEDIEVAL AND BYZANTINE ART AND ARCHITECTURE

Aubert, Marcel. *The Art of the High Gothic Era.* New York, Crown, 1964.

Beckwith, John. *Early Christian and Byzantine Art.* Harmondsworth, England, and Baltimore, Penguin, 1970.

———. *Early Medieval Art.* New York, Praeger, 1964.

Focillon, Henri. *The Art of the West in the Middle Ages.* 2nd ed. New York, Phaidon, 1963.

Grabar, André. *The Art of the Byzantine Empire.* New York, Crown, 1966.

————. *Early Christian Art*. New York, Odyssey, 1969.

————. *The Golden Age of Justinian*. New York, Odyssey, 1967.

Hollander, Hans. *Early Medieval Art*. New York, Universe, 1974.

Hubert, Jean, Jean Porcher, and W. F. Volbach. *The Carolingian Renaissance*. New York, Braziller, 1970.

————. *Europe of the Invasions*. New York, Braziller, 1969.

Hutter, Irmgard. *Early Christian and Byzantine Art*. New York, Universe, 1971.

Lasko, Peter. *Ars Sacra: 800–1200*. Baltimore, Penguin, 1972.

Martindale, Andrew. *Gothic Art*. New York, Praeger, 1967.

Swarzenski, Hanns. *Monuments of Romanesque Art*. 2nd ed. Chicago, University of Chicago Press, 1967.

Volbach, W. F. *Early Christian Art*. New York, Abrams, 1962.

Zarnecki, George. *Art of the Medieval World*. New York, Abrams, 1975.

————. *Romanesque Art*. New York, Universe, 1971.

RENAISSANCE ART AND ARCHITECTURE

Benesch, Otto. *The Art of the Renaissance in Northern Europe*. 2nd ed. New York, Phaidon, 1965.

Blunt, Anthony. *Art and Architecture in France: 1500 to 1700*. 3rd ed. Baltimore, Penguin, 1970.

Chastel, André. *The Flowering of the Italian Renaissance*. New York, Odyssey, 1965.

———. *Studios and Styles of the Italian Renaissance*. New York, Odyssey, 1966.

Gilbert, Creighton. *History of Renaissance Art*. New York, Abrams, 1973.

Hartt, Frederick. *History of Italian Renaissance Art*. New York, Abrams, 1969.

Keller, Harald. *The Renaissance in Italy*. New York, Abrams, 1969.

Levenson, Jay A., ed. *Circa 1492: Art in the Age of Exploration*. Washington, D.C., National Gallery of Art; New Haven, Conn., Yale University Press, 1991.

Murray, Linda. *The High Renaissance*. New York, Praeger, 1967.

———. *The Late Renaissance and Mannerism*. New York, Praeger, 1967.

Paatz, Walter. *The Arts of the Italian Renaissance*. Englewood Cliffs, N.J., Prentice-Hall, 1974.

Shearman, John. *Mannerism*. Harmondsworth, England, and Baltimore, Penguin, 1967.

Smart, Alastair. *The Renaissance and Mannerism Outside Italy*. New York, Harcourt Brace Jovanovich, 1972.

White, John. *Art and Architecture in Italy: 1250 to 1400.* Baltimore, Penguin, 1966.

Wundram, Manfred. *Art of the Renaissance.* New York, Universe, 1972.

BAROQUE AND ROCOCO ART AND ARCHITECTURE

Andersen, Liselotte. *Baroque and Rococo Art.* New York, Abrams, 1969.

Bazin, Germain. *Baroque and Rococo.* New York, Praeger, 1964.

Held, Julius, and Donald Posner. *17th and 18th Century Art.* New York, Abrams, 1971.

Hempel, Eberhard. *Baroque Art and Architecture in Central Europe.* Baltimore, Penguin, 1965.

Hubala, Erich. *Baroque and Rococo Art.* New York, Universe, 1976.

Kubler, George, and Martin Soria. *Art and Architecture in Spain and Portugal and Their American Dominions: 1500 to 1800.* Harmondsworth, England, and Baltimore, Penguin, 1959.

Martin, John R. *Baroque.* New York, Harper & Row, 1977.

Soehner, Halldor, and Arno Schönberger. *The Rococo Age: Art and Civilization of the Eighteenth Century.* New York, McGraw-Hill, 1960.

Summerson, John. *The Architecture of the Eighteenth Century.* London, Thames and Hudson, 1986.

Tapie, Victor L. *The Age of Grandeur: Baroque Art and Architecture.* New York, Praeger, 1961.

Wittkower, Rudolf. *Art and Architecture in Italy: 1600 to 1750.* 3rd ed. Harmondsworth, England, and Baltimore, Penguin, 1973.

MODERN ART AND ARCHITECTURE (19TH AND 20TH CENTURIES)

Arnason, H. H. *History of Modern Art.* 2nd ed. Englewood Cliffs, N.J., Prentice-Hall, 1978.

Atkins, Robert. *Artspeak: A Guide to Contemporary Ideas, Movements, and Buzzwords.* New York, Abbeville Press, 1990.

Barthes, Roland. *Camera Lucida: Reflections on Photography.* New York, Noonday Press, 1972.

Britt, David, ed. *Modern Art: Impressionism to Post-Modernism.* Boston, Bulfinch Press, Little, Brown, 1989.

Burnham, Jack. *Beyond Modern Sculpture.* New York, Braziller, 1968.

Chipp, Herschel B. *Theories of Modern Art: A Source Book by Artists and Critics.* Berkeley, University of California Press, 1968.

Evers, Hans G. *The Art of the Modern Age.* New York, Crown, 1970.

Foster, Hal, ed. *The Anti-Aesthetic: Essays in Postmodern Culture.* Seattle, Bay Press, 1983.

Frampton, Kenneth. *Modern Architecture: A Critical History.* London, Thames and Hudson, 1985.

Haftmann, Werner. *Painting in the Twentieth Century.* 2 vols. Rev. ed. New York, Praeger, 1965.

Hamilton, George Heard. *Painting and Sculpture in Europe. 1880 to 1940*. Baltimore, Penguin, 1972.

Hansen, Hans J. *Late Nineteenth Century Art*. New York, McGraw-Hill, 1972.

Hitchcock, Henry-Russell. *Architecture: Nineteenth and Twentieth Centuries*. 4th ed. Baltimore, Penguin, 1977.

Hofmann, Werner. *Art in the Nineteenth Century*. London, Faber and Faber, 1960.

Hunter, Sam, and John Jacobus. *Modern Art*. New York, Abrams, 1977.

Licht, Fred. *Sculpture: 19th and 20th Centuries*. Greenwich, Conn., New York Graphic Society, 1967.

Lucie-Smith, Edward. *Art Now: From Abstract Expressionism to Super-realism*. New York, Morrow, 1977.

Novotny, Fritz. *Painting and Sculpture in Europe: 1780 to 1880*. Baltimore, Penguin, 1960.

Pevsner, Nikolaus. *The Sources of Modern Architecture and Design*. New York, Praeger, 1968.

Raven, Arlene, et al., eds. *Feminist Art Criticism: An Anthology*. New York, UMI Research Press, 1989

Rewald, John. *The History of Impressionism*. New York, Museum of Modern Art, 1973.

———. *Post-Impressionism: From Van Gogh to Gauguin*. New York, Museum of Modern Art, 1978.

Richardson, Tony, and Nikos Stangos, eds. *Concepts of Modern Art*. New York, Harper & Row, 1974.

Rowland, Kurt. *A History of the Modern Movement.* New York, Van Nostrand, 1973.

Said, Edward. *Orientalism.* New York, Vintage Books, 1979.

Schug, Albert. *Art of the Twentieth Century.* New York, Abrams, 1972.

Schultze, Jürgen. *Art of the Nineteenth Century.* New York, Abrams, 1972.

Vogt, Adolf M. *Art of the Nineteenth Century.* New York, Universe, 1973.

Wallis, Brian, ed. *Art after Modernism: Rethinking Representation.* New York, New Museum of Contemporary Art, 1984.

Important news and criticism pertaining to contemporary art, architecture, and design is to be found in art journals and periodicals:
Artforum, Art in America, Art Journal, Art News, Art Week, Arts Magazine, Feminist Art Journal, Flash Art, Graphis, Industrial Design, Metropolis, New Art Examiner, October (American)
Arts Review (British)
L'Oeil, Opus International (French)
Das Kunstwerk (German)
Art International (Swiss)

Blumenson, John J. G. *Identifying American Architecture: A Pictorial Guide to Styles and Terms, 1600–1945.* Rev. ed. Nashville, American Association for State and Local History, 1981.

Brown, Milton. *American Art to 1900.* New York, Abrams, 1977.

Green, Samuel M. *American Art: A Historical Survey.* New York, Ronald Press, 1966.

Higgins, Nathanial. *The Harlem Renaissance.* New York, Oxford University Press, 1971.

McLanathan, Richard. *The American Tradition in the Arts.* New York, Harcourt Brace Jovanovich, 1968.

Mendelowitz, Daniel M. *A History of American Art.* 2nd ed. New York, Holt, Rinehart & Winston, 1970.

Popeliers, John C., S. Allen Chambers, Jr., and Nancy B. Schwartz. *What Style Is It? A Guide to American Architecture.* Washington, D.C., Preservation Press, 1983.

Rose, Barbara. *American Art Since 1900.* Rev. and exp. ed. New York, Holt, Rinehart & Winston, 1975.

Wilmerding, John. *American Art.* Harmondsworth, England, and Baltimore, Penguin, 1976.

MUSEUMS, COLLECTING, AND CONNOISSEURSHIP

Ames, Michael. *Museums, the Public, and Anthropology: A Study in the Anthropology of Anthropology.* Vancouver, University of British Columbia Press, 1986.

Berenson, Bernard. *Rudiments of Connoisseurship*. New York, Schocken, 1962.

Dolloff, Francis W., and Roy L. Perkinson. *How to Care for Works of Art on Paper*. 2nd ed. Boston, Museum of Fine Arts, 1977.

Fall, Frieda Kay. *Art Objects: Their Care and Preservation*. La Jolla, Calif., Laurence McGilvery, 1973.

Holst, Niels Voll. *Creators, Collectors and Connoisseurs*. New York, Putnam, 1967.

Kaye, Myrna. *Fake, Fraud, or Genuine? Identifying Authentic American Antique Furniture*. Boston, Bulfinch Press, Little, Brown, 1991.

Keck, Caroline K. *How to Take Care of Your Paintings*. New York, Scribner's, 1978.

Plenderleith, Harold J. *The Conservation of Antiquities and Works of Art: Treatment, Repair and Restoration*. London, Oxford University Press, 1956.

Savage, George. *Forgeries, Fakes and Reproductions*. New York, Praeger, 1964.

Zigrosser, Carl, and Christa M. Gaehde. *Guide to the Collecting and Care of Original Prints*. New York, Crown, 1965.

Also of interest in this area are such journals as *Antiques, Apollo, International Art Market,* and *Print Collector's Newsletter.*

TECHNIQUES AND PHYSICAL PROPERTIES

Brady, George S. *Materials Handbook*. 9th ed. New York, McGraw-Hill, 1963.

Herberts, Kurt. *Complete Book of Artists' Techniques.* New York, Praeger, 1969.

Jensen, Lawrence N. *Synthetic Painting Media.* Englewood Cliffs, N.J., Prentice-Hall, 1964.

Mayer, Ralph. *The Artists' Handbook of Materials and Techniques.* 3rd ed. New York, Viking, 1970.

Quick, John. *Artists' and Illustrators' Encyclopedia.* 2nd ed. New York, McGraw-Hill, 1977.

PHOTOGRAPHY

Eder, Josef Maria. *The History of Photography.* New York, Dover, 1978. (First pub.1932.)

Gernsheim, Helmut, and Alison Gernsheim. *The History of Photography.* New York, Oxford University Press and McGraw-Hill, 1955, 1969.

Newhall, Beaumont. *The History of Photography from 1839 to the Present Day.* 5th ed. New York, Museum of Modern Art, 1988.

Rosenblum, Naomi. *A World History of Photography.* New York, Abbeville Press, 1984.

Sobieszek, Robert A. *Masterpieces of Photography from the George Eastman House Collections.* New York, Abbeville Press, 1985.

Szarkowski, John. *Photography Until Now.* New York, Museum of Modern Art, 1989.

Witkin, Lee D., and Barbara London. *The Photograph Collector's Guide.* Boston, New York Graphic Society, 1979.